IMAGES
of America

EARLY
BEVERLY HILLS

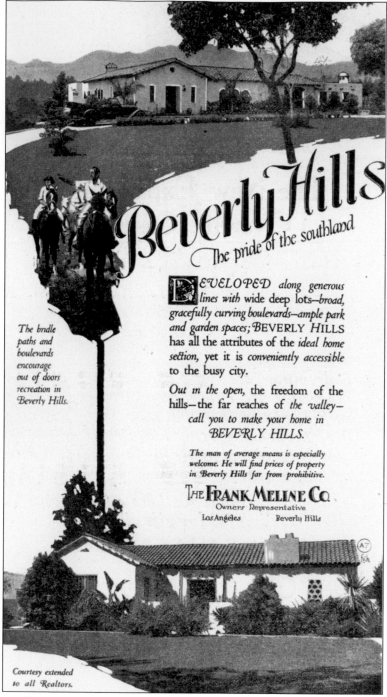

REAL ESTATE ADVERTISEMENT, 1922. The Frank Meline Company was one of several developers who sold property in Beverly Hills at all price ranges.

ON THE COVER: CITY HALL, 1932. This Spanish Colonial Revival building set the style of architecture for the 1930s in Beverly Hills.

IMAGES

of America

EARLY
BEVERLY HILLS

Marc Wanamaker

ARCADIA

Published by Arcadia Publishing
Charleston SC, Chicago IL, Portsmouth NH, San Francisco CA

Printed in Great Britain

Library of Congress Catalog Card Number: 2005930109

For all general information contact Arcadia Publishing at:
Telephone 843-853-2070
Fax 843-853-0044
E-mail sales@arcadiapublishing.com
For customer service and orders:
Toll-Free 1-888-313-2665

Visit us on the Internet at www.arcadiapublishing.com

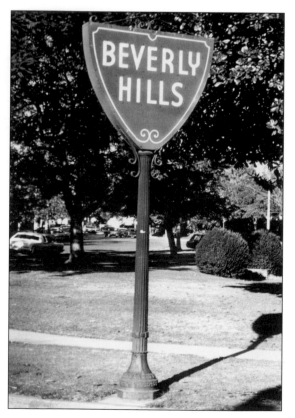

BEVERLY HILLS SHIELD, 1964. The shield signs were placed at the city limits during the 1930s, giving Beverly Hills its own identity as an island within the city of Los Angeles.

CONTENTS

ACKNOWLEDGMENTS

The research for this book has taken more than 30 years of collecting information, photographs, and memorabilia. For preservation and further study, the author has been creating an archive for the Beverly Hills Historical Society. The chapter about the Beverly Hills Hotel was written by Beverly Hills historian Robert S. Anderson, whose grandmother Margaret Anderson and her son Stanley built and operated the Beverly Hills Hotel. The information and photographs contained in this book are from Bison Archives, a historical archive of Southern California and the Los Angeles area as well as the development of the motion picture and television industries in the United States.

Marc Wanamaker created Bison Archives in 1971 while researching historical data of the motion picture studios in the United States for an encyclopedic history. The archive was compiled from thousands of sources of photographs and research materials, particularly from motion picture studios' research libraries and film location files that the studios had been collecting since 1915. Many of the photographs in this book have never been published and are a historical record of Beverly Hills streets, estates, buildings, and landmarks.

The photographs for the Beverly Hills Hotel chapter were provided by its author, Robert S. Anderson, who continues to research and archive the history of his family and their pioneering involvement with the development of Beverly Hills.

The author wishes to thank the many institutions and individuals over the years that helped with the collection of research on the history of Beverly Hills. Some of the more important contributors to the research of Beverly Hills include the following: Jill Tavelman Collins, president of the Beverly Hills Historical Society; Robert S. Anderson, Winston Millet, and Phyllis Lerner, past founders and presidents of the Beverly Hills Historical Society; Elinor Quinlan and Fred E. Basten; the Beverly Hills Parks and Recreation Department; Jeff Hyland; Marty Geimer; Ira Goldberg; and Alan Bunnage. Some of the historical source materials were researched from Pierce E. Benedict's *History of Beverly Hills*, Charles Lockwood, *Beverly Hills Historic Resources Survey* by Johnson and Heumann Research Associates, the *Beverly Hills Citizen Newspaper* of 1947, and the voluminous research files of Bison Archives.

INTRODUCTION

What is now Beverly Hills was once a part of the overall province of Spanish California, which was claimed in the 16th century. The semi-arid landscape was surrounded by hills and mountains where the Native Americans lived for centuries before the white man arrived. The area of Los Angeles was first explored in 1769 by the new Spanish governor of California, Capt. Gaspar de Portola, and his Spanish land party, which was scouting sites suitable for Franciscan missions and civilian settlements. When Missions San Gabriel and San Fernando were established in the 1770s, the Indian converts came to be called the Gabrielenos and Fernandenos. In 1781, during the reign of King Carlos III, a small group of settlers established the pueblo of Los Angeles for Spain, naming the new settlement El Pueblo de la Reina de Los Angeles. It remained an outpost of New Spain until 1822, when Mexico broke away and established a new, independent nation. The old Spanish realm of California, including the city of Los Angeles, became a colony of Mexico. The Mexican government designated Los Angeles a city in 1835. The Mexican phase—known as the Rancho period—lasted until the end of the Mexican War, from 1846 to 1848.

The Beverly Hills area was explored by Captain Portola on August 3, 1769. The Spanish party followed the old Indian trails into this area, which is now Wilshire Boulevard. They had originated their expedition from Mexico, and their mission was to find, in the name of the king of Spain, the first settlements in the Province of Alta California. The party to Monterey included Fr. Junipero Serra, who was to establish a mission system along the coast of California. A plaque commemorating the Portola expedition was placed in La Cienega Park in 1959. The plaque reads, "The Expedition of Don Gaspar De Portola from Mexico passed this way en route to Monterey to begin the Spanish colonization of California with Capt. Don Fernando Rivera Y Moncada, Lt. Don Pedro Fages, Sgt. J. Francisco Ortega, and fathers Juan Crespi, Francisco Gomez. Portola and his party camped near this spot on August 3, 1769."

Along the foothills were streams that flowed into the lower flatlands, which were covered with herbs and watercress. The party named the spot "Spring of the Sycamores of St. Stephen." As colonists migrated to the new land, several individuals settled in and around the "Beverly Hills" area. One of the first to settle at the Los Angeles pueblo on the River Porciuncula in 1781 was Eugenio Valdez, a soldier from Sonoma, along with his parents and his young bride. That same year, a six-year-old boy named Vicente Ferrer Villa came to California with his family and another group of settlers who came this way via San Gabriel. These two families were linked with the first Beverly Hills settler and owner, Maria Rita Valdez. The soldier was her father, and the young boy grew up to become her husband. In 1828, the Valdez family called their settlement "Rodeo de las Aguas," or "the gathering of the waters" that came from the meeting of the underground artesian streams flowing out of the foothills. Coldwater Canyon's streams were named Cañada de las Aguas Frias, and Benedict Canyon's were called Cañada de los Encinos.

BRANDS OF THE RANCHOS

Mariano Villa

José Antonio Rocha
of Rancho La Brea

Maria Rita Valdez de Villa

Benjamin Davis Wilson

Domingo Amestoy

Edward A. Preuss

Remi Nadeau

Hammel & Denker

LOCAL RANCHOS BRANDS, 1850s–1860s. These are the livestock brands of the ranchos that were located between present-day Hollywood in the east and the area that would later become Westwood in the west.

One

THE POST-RANCHO PERIOD
1880–1907

With the end of the 19th century, the ranchos of the Los Angeles area were becoming subdivided, having been purchased by Anglo entrepreneurs. Nearly the entire rancho was divided into 75-acre farm lots, with the center being the proposed town of Santa Maria. By the 1880s, the rancho began to be acquired parcel by parcel by Charles Denker and Henry Hammel, managers of the elegant and prosperous United States Hotel, located at Main and Market Streets in downtown Los Angeles. The Hammel and Denker Ranch soon grew into a country settlement, which became the first farming community in the area. With the land boom of the 1880s, easterners flocked to California in search of real estate bargains. In 1887, the Coldwater School District was formed and a small school opened at the entrance to Coldwater Canyon. In 1900, with the boom in the oil business, a group of investors including Burton Green, Charles A. Canfield, Max Whittier, Frank Buck, Henry Huntington, and W. G. Kerckhoff, through their Amalgamated Oil Company, purchased the Hammel and Denker Ranch holdings for development. With the coming of rail transportation throughout the Los Angeles area, the lone station on their property was named Morocco Junction. The only place where you could find this name was on a trolley station that was once located at what is now Santa Monica Boulevard and Canon Drive. After drilling for oil, the company instead struck water. The company reorganized into the Rodeo Land and Water Company and turned to the development of the land into a residential community in 1907.

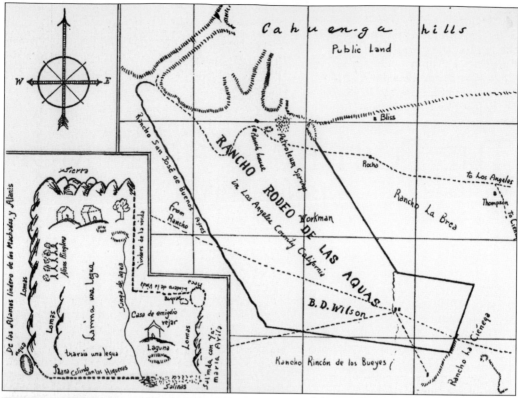

MAP OF EL RODEO DE LAS AGUAS RANCHO, 1868. When Maria Rita Valdez de Villa had her rancho property certified in 1868, G. Howard Thompson, deputy U.S. surveyor, mapped out the rancho's boundaries. The inset shows the drawing made from the original rancho map of 1838, which accompanied Maria Rita's original claim.

RODEO DE LAS AGUAS PLAQUE. This plaque in Coldwater Park was dedicated by the Native Daughters of the Golden West in 1949 to commemorate the "meeting of the streams" that freely flowed out of the hills into Rancho San Antonio or Rancho Rodeo De Las Aquas.

LAST RANCHO INDIAN BATTLE SITE. This plaque marks the site of the last Indian battle, in 1852, on Rancho San Antonio. The site at Chevy Chase and Benedict Canyon Drive was commemorated in 1930 by the Daughters of the American Revolution.

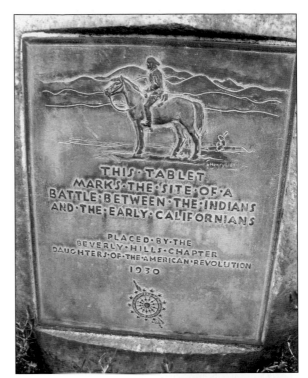

ANTONIO ROCHES ADOBE, 1900. This crumbling adobe house was one of several on the Hammel and Denker Ranch that dominated the area in and around what is now Beverly Hills.

ROCHES ADOBE, 1900. Pictured is one of several buildings that later constituted the Hammel and Denker Ranch during the 1880s. The Roches Adobe buildings were once located in the area of what is now Third Street and Robertson Boulevard, just outside the present-day boundaries of Beverly Hills.

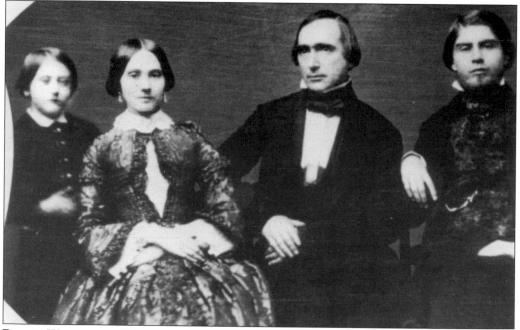

BENITO WILSON AND FAMILY, 1878. Benjamin Davis Wilson is pictured with his second wife, her son Edward, and her nephew Tom. Wilson was a former mayor of Los Angeles in 1951, and by 1865, along with his partners he formed the Pioneer Oil Company. He and Henry Hancock purchased Rancho San Antonio (El Rodeo de las Aguas) in 1854 from Dona Maria Valdez de Villa.

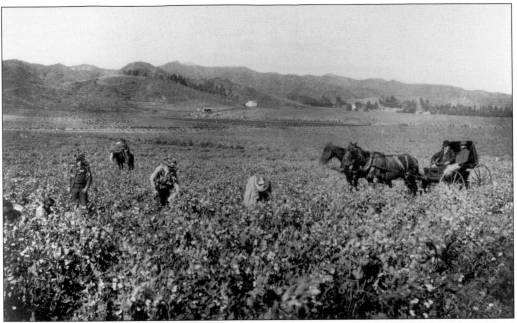

GEORGE HANSEN RANCH, 1890s. The Hansen property was located near Sunset and Alpine at what was once a part of the Maria Valdez land grant. George Hansen was a Los Angeles city surveyor who mapped out the subdivision of the entire former Rancho de las Aguas in the 1880s.

HAMMEL AND DENKER RANCH, 1903. Land purchased in 1881 from Dr. Edward A. Preuss became the Hammel and Denker Ranch, which constituted the former Rancho de Las Aguas properties. The farmland was planted predominately with lima beans and was known for years as the largest farm in the area.

HAMMEL AND DENKER RANCH, 1903. Henry Hammel and his partner Charles Denker had been famous in Los Angeles as hotel managers. Parcel by parcel, they purchased large areas of the original Rancho de las Aguas for development as farmland, a cattle ranch, and a future town they named Morocco.

HAMMEL AND DENKER RANCH, 1903. This is one of the ranch buildings that was a part of this large cattle ranch near the present-day corner of Robertson Boulevard and Pico. The growth of the Hammel and Denker businesses marked the beginning of a new era of development in the area.

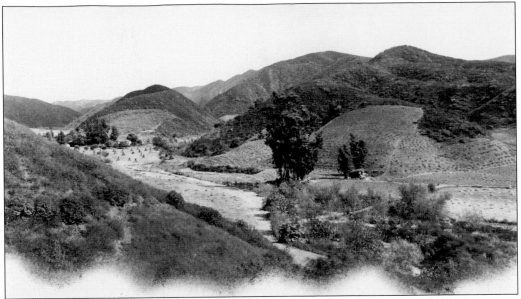

BENEDICT CANYON, C. 1890. In 1868, Edson A. Benedict purchased a claim of property in what was later named Benedict Canyon, within the original Rancho de las Aguas property north of Sunset Boulevard. By 1876, Edson's son Pierce purchased 230 acres of land adjoining his father's property and built a house establishing the Benedict family as the principal land owners in the canyon.

BENEDICT CANYON, C. 1890. This photograph looks south to Sunset Boulevard. The canyon did not become one of the principal residential areas in Beverly Hills until the 1920s. After his father's death, Pierce Benedict transformed the canyon into farmland, planting walnuts, vegetables, and beans.

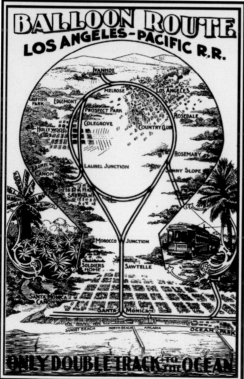

COLDWATER CANYON, 1910. This view looks north up Coldwater Canyon at the Haines lemon farm and the Sheffler residence. The Rodeo Land and Water Company later developed the canyon as one of the prime residential areas in Beverly Hills north of Sunset Boulevard.

BALLOON ROUTE OF THE LOS ANGELES PACIFIC ELECTRIC, 1906. This tourist trolley excursion brought tourists to areas of future development to interest them in buying real estate in the Los Angeles area. The Hammel and Denker future development of their town "Morocco Junction" can be seen on the balloon route map.

Two

Burton Green and City Founders
1907–1920

The driving force behind the new Rodeo Land and Water Company was Burton E. Green, who was born near Madison Wisconsin on September 6, 1868. He led the founders of Beverly Hills through the ups and downs of development and finance. Green built a magnificent estate on Lexington Road that became one of the first landmarks in the area. Mr. Green was married to Lilian Wellborn, the daughter of Judge Olin Wellborn, and they had three daughters: Dorothy (Dolly), Liliore, and Burton, who was named after her father.

In 1900, Charles Canfield purchased the Hammel and Denker Ranch with his partners, Max Whittier, W. G. Kerckhoff, Frank Buck, Burton Green, William F. Herrin, W. S. Porter, Frank H. Balch, and Henry Huntington. They renamed the old ranch Morocco Junction. The Amalgamated Oil Company was formed for oil exploration of the area. After drilling unsuccessfully, they created a new company in 1906 to develop the land. The Rodeo Land and Water Company was set up to create a new and exclusive community. Guided by its president, Burton E. Green, the new corporation was dedicated to develop a residential town with broad tree-lined streets, spacious lots, and generous parks.

The new community was given a new name, "Beverly," after Beverly Farms in Massachusetts, an area Mr. Green fondly remembered from his youth for its beautiful landscape. On January 23, 1907, the subdivision was officially recorded. Gently curving streets bordered with palms, acacias, and pepper trees and the planned Park Way were created. After a year of prime infrastructure construction, advertisements were placed in the papers to attract potential buyers who could come by public transportation. The Peck Building, an English-style, two-story, frame-and-stucco building, was being erected on the southwest corner of Beverly Drive and Burton Way (now South Santa Monica) to house a general store, post office, and an upstairs recreation hall. South of the railroad tracks on Santa Monica Boulevard were only three north-south streets: Canon, Beverly, and Rodeo Drives, which ended at Wilshire Boulevard.

By 1910, due to lackluster interest in the planned community, a new plan was introduced to attract visitors to Beverly Hills. When the Beverly Hills Hotel was completed in 1912, the hotel visitors could stay at the hotel and take tours of the area to see where they may want to build a home. There were horseback trips into the canyons and hills to explore building sites. Several factors, including the need for a larger school system and the fear of a water shortage, later inspired a movement for Beverly Hills to incorporate. Incorporation was granted on January 28, 1914.

BURTON E. GREEN, 1900. Green was responsible for naming Beverly Hills. At 16 years old, he moved with his family to California, where he continued his education. After graduating from school, he became one of the founders of the Associated Oil Company of California and, later, the president of the Bellridge Oil Company of Kern County.

BEVERLY DRIVE, SOUTH OF SUNSET BOULEVARD, 1916. With the prestige of the new hotel, Beverly Hills took on a new spirit and activity. Wilbur Cook, a prominent landscape architect from New York was appointed to create the master plan. It included the preparation of estate lots north of Sunset surrounding the Beverly Hills Hotel and smaller lots south of Sunset Boulevard.

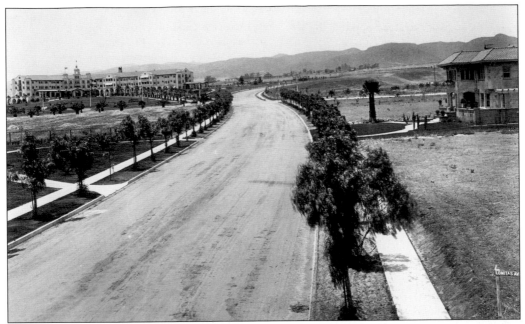

CRESCENT DRIVE AT LOMITAS AVENUE, 1915. In 1907, on the right side of Crescent Drive, real estate man Henry C. Clark built the first house in Beverly Hills. The Beverly Hills Hotel, built in 1912, can be seen at the top left of the photograph on Sunset Boulevard and Crescent Drive.

BEVERLY DRIVE AND PARK WAY, C. 1913. This house, located on the northeast corner of Park Way and Beverly Drive, was one of the first to be built in Beverly Hills. Residential lots south of Sunset Boulevard were priced between $1,000 and $1,500. The Park Way house was one of the first spec houses in the city and stands today as a reminder of the first phase of development of Beverly Hills.

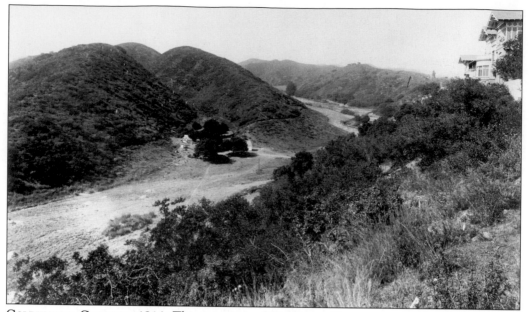

COLDWATER CANYON, 1914. This is a view of Coldwater Canyon just north of what is now Coldwater Park. Oilman Kirk B. Johnson's estate can be seen at the right, overlooking the canyon. It was one of the earliest mansions built by Thomas Thorkildsen in 1912.

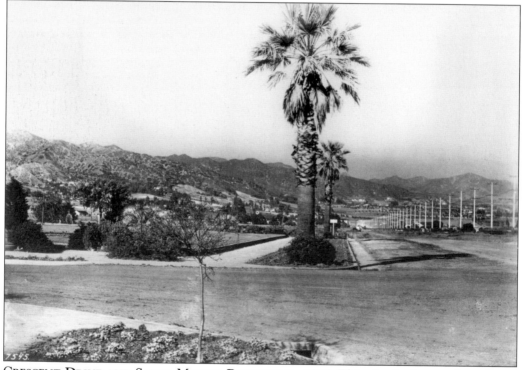

CRESCENT DRIVE AND SANTA MONICA BOULEVARD, 1916. This view looks east down Santa Monica Boulevard toward the town of Sherman. The Pacific Electric streetcar lines ran along Santa Monica Boulevard through Beverly Hills until 1965. Beverly Hills was the main stop either before entering Sherman to the east or Santa Monica to the west.

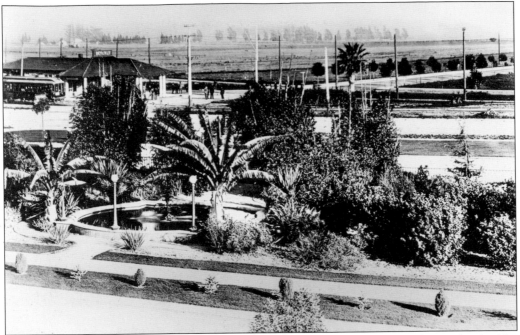

PARK WAY AT BEVERLY DRIVE, 1915. Park Way was planned as a three-block stretch of public parkland named Beverly Gardens. It was intended to give a first impression of Beverly Hills to the many visitors who traveled through the area. The park, with its grassy areas, trees, fountain, and pond was the first thing that passengers would see from the Pacific Electric Beverly Station at the southeast corner of Santa Monica Boulevard and Canon Drive.

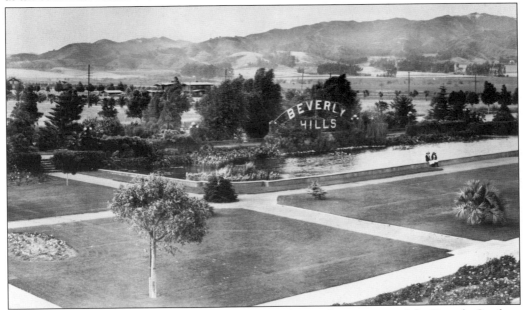

PARK WAY AT BEVERLY DRIVE, 1915. Located on the northeast corner of the Beverly Gardens was the massive lily pond. A huge arched sign read "Beverly Hills." Beverly Hills was still considered a rural community, though it had little vegetation—not a common sight in Los Angeles at this time.

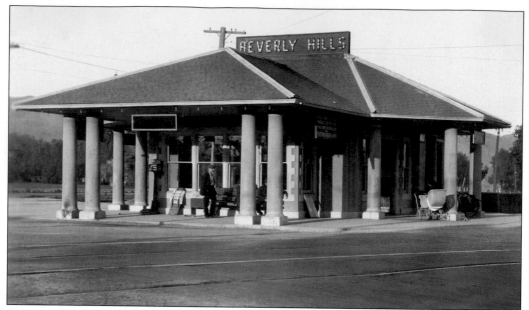

BEVERLY HILLS STATION, 1916. Built in 1896 on the southeast corner of Santa Monica Boulevard and Canon Drive, the Beverly Hills Station was both a Southern Pacific and Pacific Electric depot. For over 50 years, freight and streetcar lines ran through the city of Beverly Hills until all rail traffic ended in the mid-1960s. The old Morocco train station was demolished in 1930 to make way for the city's new post office.

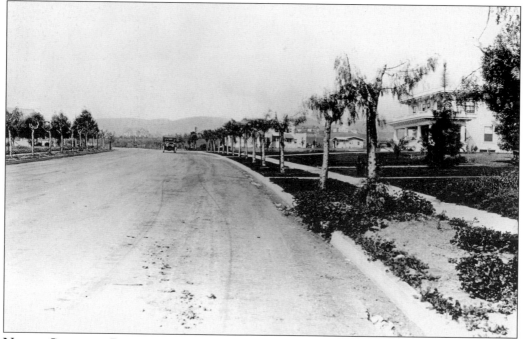

NORTH CRESCENT DRIVE, 1914. By the mid-1910s, Beverly Hills was still considered in a state of development with many open and unsold lots and very little vegetation landscaping the area. The development of Beverly Hills took many years with its ups and downs until the mid-1920s, when there was a real estate boom in the Los Angeles area.

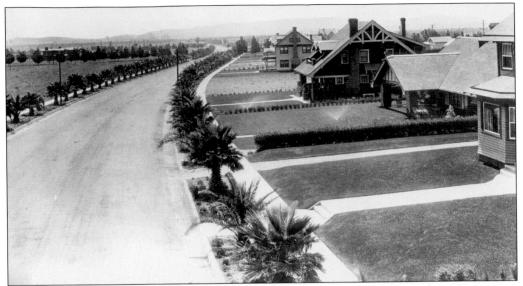

CANON DRIVE SOUTH TO SANTA MONICA BOULEVARD, 1918. This view of Canon Drive shows a few homes built on the west side of the street. In 1907, when the first subdivision was begun, three streets, Rodeo, Beverly and Canon Drives were opened. By 1911, there were only six houses north of Santa Monica Boulevard. The Pacific Electric depot at Canon and Santa Monica Boulevard was the only rail stop in Beverly Hills at the time.

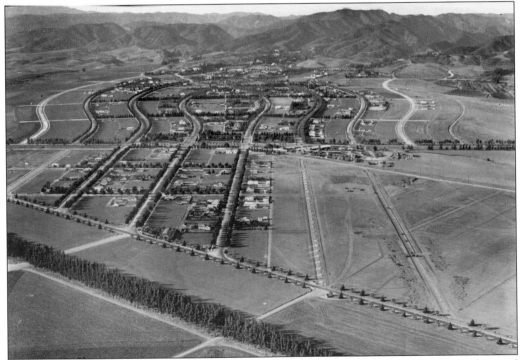

BEVERLY HILLS, 1920. This view of Beverly Hills shows the city street grid system of curved roads that created a tulip-shaped plan that was unique to the area. Below is Wilshire Boulevard, and running in the center is Santa Monica Boulevard. The mouths of Benedict and Coldwater Canyons can be seen overlook the newly developed city.

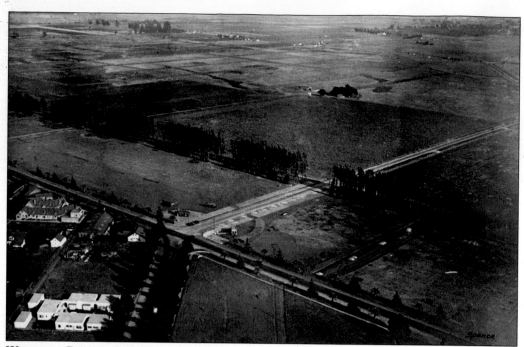

WILSHIRE BOULEVARD AND BEVERLY DRIVE, 1920. Looking southeast, there were still cultivated farmlands that were once a part of the famous Hammel and Denker Ranch of the 19th century. Only three years later, the intersection would be the center of commerce and culture, with the construction of stores, offices, and a motion picture theater.

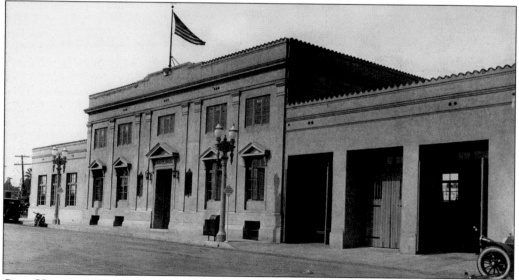

CITY HALL, 1925. On January 28, 1914, a certificate of incorporation was issued forming the legal entity of Beverly Hills. Shortly thereafter, the trustees of the new city elected Pierce Benedict as president and William T. Gould as president of the board to act in the capacity of mayor. One of the first two ordinances established the first city hall in the Peck Building at the southwest corner of Beverly Drive and Burton Way. The Beverly Hills Fire Department was organized in 1925, and the existing police department was situated in the new city hall building on Burton Way at Crescent Drive.

24

Three

THE BEVERLY HILLS HOTEL
1912–1940

Margaret J. Anderson, a single parent with two children, was a pioneer in the development of Southern California. Possessed of an abiding faith in the future of Los Angeles, particularly that section westward to the hills, she contributed, along with her son Stanley S. Anderson, materially to the growth and development of Hollywood and Beverly Hills, in two large hotel enterprises which she owned and developed—The Hollywood Hotel and The Beverly Hills Hotel.

Anderson was born in Iowa of Scotch-Irish parentage. Her father, Rev. Robert Boag, a Presbyterian clergyman, moved with his family to California in 1874, and settled in Wilmington. Wilmington, then an important military post and port was regarded at the time to have a greater future than Los Angeles itself. After Margaret's marriage to Lewis Anderson, the Andersons essayed ranching near Alhambra and were among the early navel orange developers in Southern California. She was left a widow with two small children, and Mrs. Anderson was persuaded to purchase and undertake the management of the Hollywood Hotel, then just completed as a nucleus for the development of Hollywood—an ambitious real estate subdivision. The original Hollywood Hotel had accommodations for only 16 guests. Three times it was enlarged, and by the time Mrs. Anderson surrendered her lease, it had grown to be one of the largest (250 rooms) and best-known hotels in Southern California.

After the failed oil exploration plans for the area were changed to create a community instead, the Rodeo Land and Water Company was formed to subdivide the land, with some streets and parkland to be laid out in lots for sale. After a few years, home sales were few and far between, with only a handful of homes—built mostly built on speculation. The Rodeo Land and Water Company at that time insisted that everything be done in the best possible manner, regardless of expense. It had to be perfect. They figured the only way they could ever sell Beverly was to get a hotel and get some people living out there.

On May 14, 1911, the Los Angeles Real Estate section of the *Los Angeles Times* announced a huge Mission-style hotel to be erected by Margaret J. Anderson in the Beverly Hills area. Anderson's motto was that her guests were entitled to the best of everything regardless of the cost. She fell right in line with the Rodeo Land Company's plan to bring in a new resort hotel. Margaret and her son Stanley had perfected their marketing and presentation to an unparalleled excellence and saw the opportunity to do everything bigger and better at Beverly and own the land, which they did not achieve at the Hollywood Hotel Development.

—By Robert S. Anderson

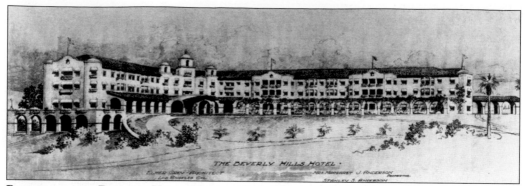

PLANS FOR THE BEVERLY HILLS HOTEL, 1911. Here is architect Elmer Grey's drawing of the Beverly Hills Hotel for Margaret J. Anderson, proprietor. Construction of the Beverly Hills Hotel began in early 1911, and the hotel opened its doors on May 1, 1912. It was quite a procession, as the majority of her clientele from Hollywood came with her. There were many unique features of the hotel, including the bungalows for guests that would return every year with their staffs and children to escape the harsh northern and eastern climates.

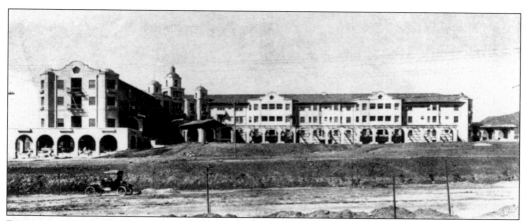

BEVERLY HILLS HOTEL UNDER CONSTRUCTION, 1912. The finishing touches to the hotel included painting, landscaping, and interior installation. The interior design would follow the Spanish Colonial general design of the building.

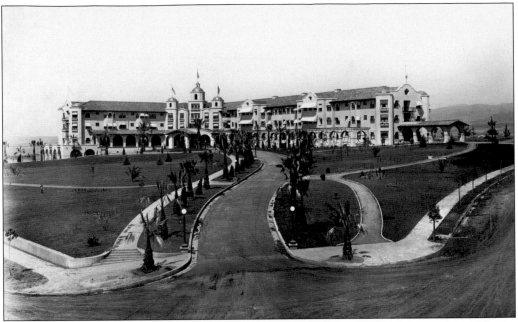

GRAND OPENING. On May 1, 1912, the Beverly Hills Hotel opened its doors to the public for the first time.

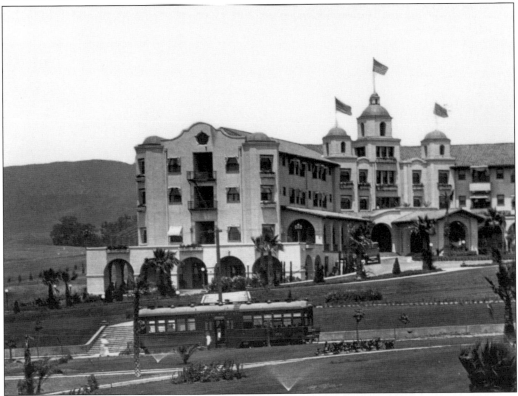

BEVERLY HILLS HOTEL, 1912. The western face of the hotel and its trolley-stop pavilion in front of the hotel on Sunset Boulevard were for guests and visitors to use.

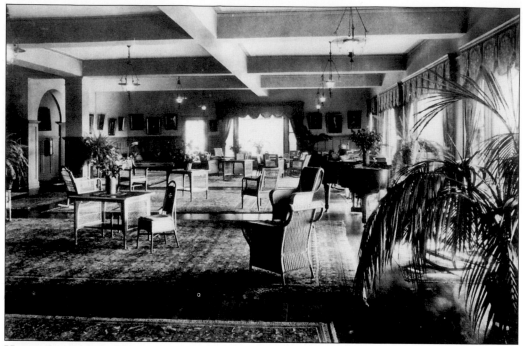

HOTEL SUNROOM. This room was where guests could relax with a view of the Pacific Ocean. The California Craftsman furniture blended well with the hotel's Spanish Colonial and Mission architectural details.

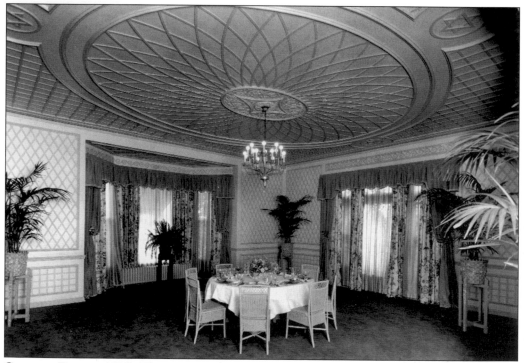

CRYSTAL ROOM, 1915. This was an elegant private room where a small dinner party could be held.

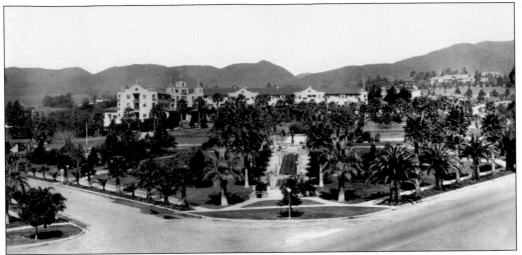

SUNSET PARK, 1915. What is now Will Rogers Park was originally part of the Beverly Hills Hotel grounds. The Anderson family donated the land to the city in 1915, creating the first municipal park in Beverly Hills.

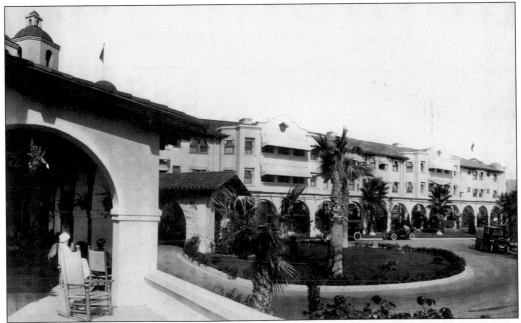

HOTEL VERANDA, 1918. Guests could watch the comings and goings of all visitors from the veranda of the hotel. The outer deck, with arches reminiscent of the California missions, was furnished with deck chairs and wicker furniture that was common during the early 1900s.

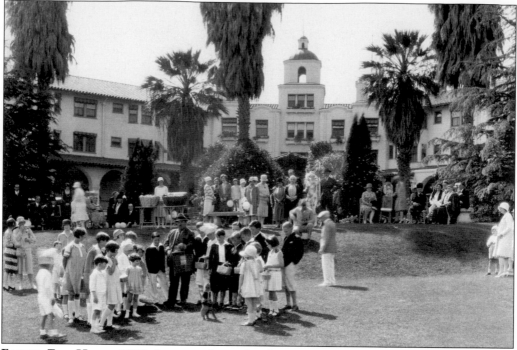

EASTER EGG HUNT, 1918. It was traditional to have an annual Easter egg hunt on the front grounds of the hotel, for the children of guests and employees alike.

HOTEL BUNGALOWS. Eldest son Stanley S. Anderson and his wife, Margaret, are pictured with sons Jack and Bob on the stoop of a bungalow. The bungalows could be rented short or long term and were a sought-after amenity.

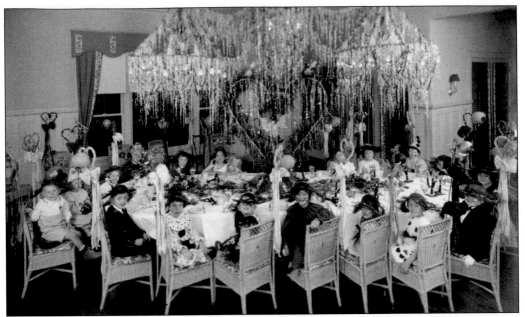

CHILDREN'S DINING ROOM, 1919. A Valentine's Day party was held in the Children's Dining room, now the location of the Polo Lounge.

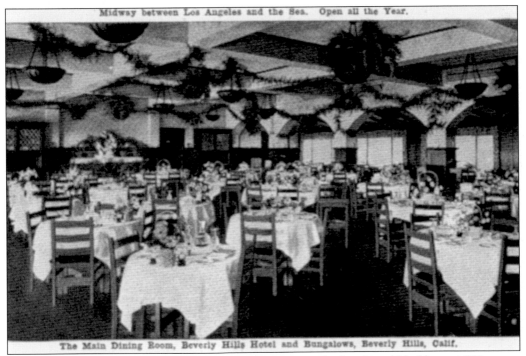

Midway between Los Angeles and the Sea. Open all the Year.

The Main Dining Room, Beverly Hills Hotel and Bungalows, Beverly Hills, Calif.

HOTEL DINING ROOM, 1919. The main dining room in the hotel could hold up to 500 guests and was connected to a kitchen area that serviced the entire hotel.

HOTEL LOBBY, 1919. This photograph is a double-opening postcard of the Beverly Hills Hotel lobby. It looks very similar today.

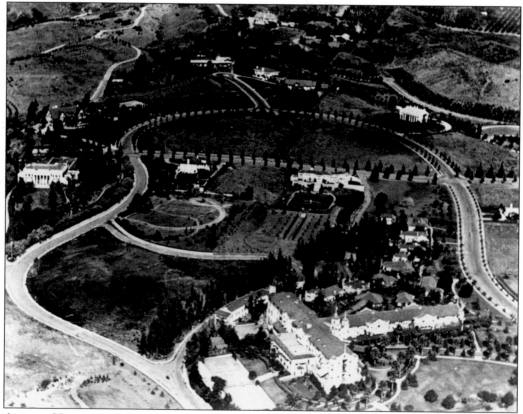

AERIAL VIEW, 1920. The barren landscape to the west of the hotel is pictured here, with the Burton Green mansion above it to the left. At this time, there were only a few stately homes in the hills above the hotel grounds, but by the end of the 1920s, more estates were dotting the hillside.

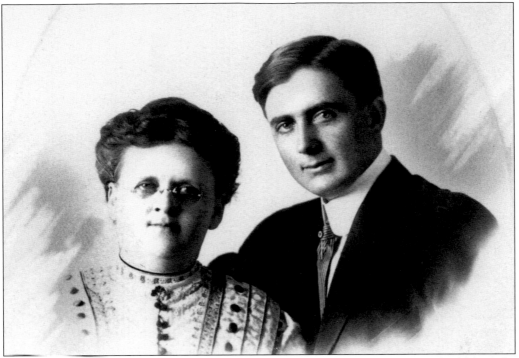

MARGARET J. ANDERSON AND SON STANLEY. Margaret Anderson, the owner-builder of the Beverly Hills Hotel, and her son Stanley, the manager, lived on the hotel's grounds.

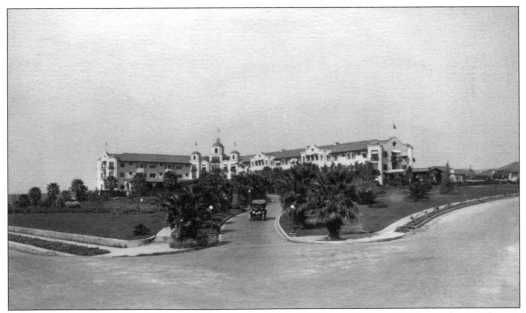

VIEW OF BEVERLY HILLS HOTEL. This view of the Mission-style hotel is from the Anderson family's leather-bound promotional book.

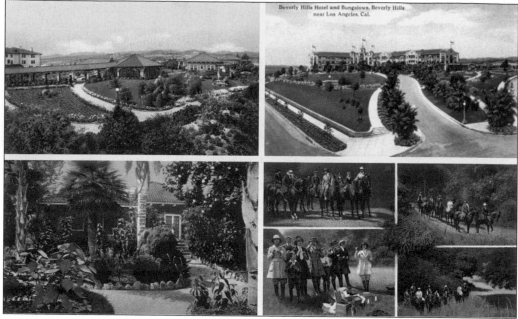

POSTCARD COMPOSITE. This card shows several views of the Beverly Hills Hotel and grounds that tourists used to send around the world.

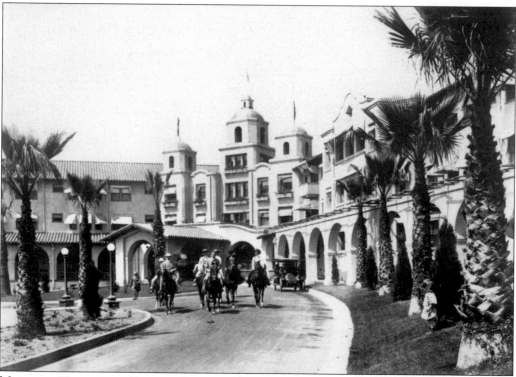

MORNING HORSEBACK RIDE TO BENEDICT CANYON, 1920. Guests leaving on a morning ride to Benedict Canyon have brunch at the Beverly Hills Hotel Camp. The food is prepared by the Beverly Hills Hotel staff and is waiting for the guests when they arrive there.

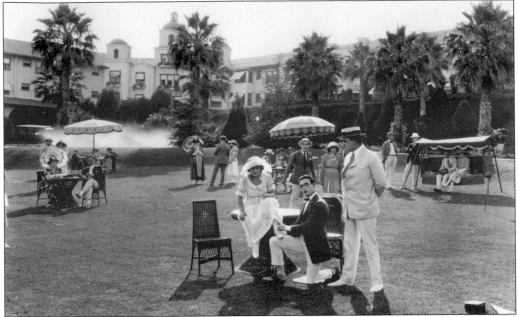

HAROLD LLOYD AT THE BEVERLY HILLS HOTEL, 1921. When Harold Lloyd needed a posh resort setting for his film *A Sailor-Made Man*, he chose the closest hotel-resort he could think of—the Beverly Hills Hotel. The scene called for Lloyd to try to see his girlfriend while avoiding the watchful eye of the girl's father.

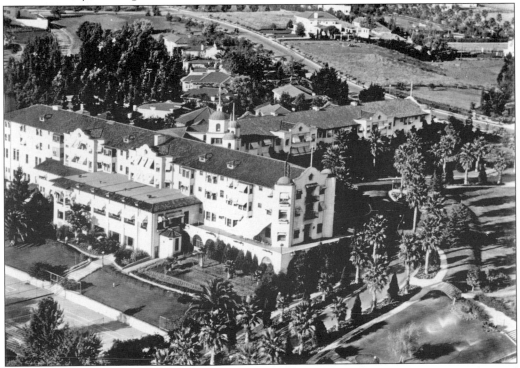

AERIAL VIEW, 1921. This view of the hotel shows the area where the tennis courts were located before the swimming pool was installed years later.

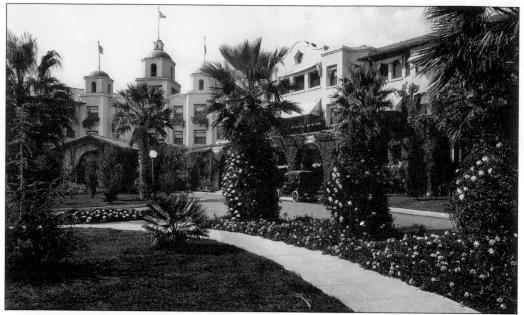

BEVERLY HILLS HOTEL, 1926. The curved approach to the hotel, which was the same design as the streets of the community, had not changed over the years, despite the front lawn being changed into a parking lot many years later.

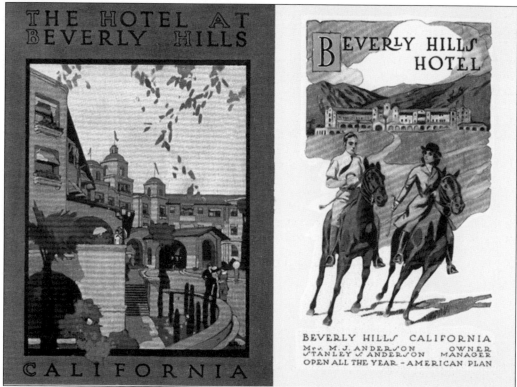

HOTEL BROCHURE, 1926. The cover of a promotional brochure for the Beverly Hills Hotel describes the amenities the hotel had to offer during the 1920s.

Four

ESTATES OF BEVERLY HILLS
1906–1940

In 1906, work began on the development of a residential community. The first three streets constructed were Rodeo, Beverly, and Canon Drives, and by 1911, three more were added—Camden, Crescent, and Rexford Drives. Street parkways were planted with palm trees, acacias, and peppers. At this time, a few of the lots were sold. Several company spec homes were under construction, with Percy Clark as the first real estate agent in the area. He set up his office in the old railway station known as Morocco Junction and renamed it Beverly Station, where he would greet prospective lot purchasers with a fancy horse-drawn carriage to take them on a tour. Clarke built the first house on Canon Drive in 1907 and later sold it for a profit when lots south of Sunset Boulevard were selling for $1,000. Before 1915, it was the only house on the entire street. About the time that Clarke was selling his first properties, the panic of 1907–1908 arrived, and there was no business until 1910, when Clarke became the selling agent and general manager of the Rodeo Land and Water Company. He had worked with Wilbur Cook, a landscape architect who designed the streets in a crescent shape—unheard of at the time.

Between 1920 and 1925, the population grew from less than 700 to 7,500 people. By 1926, it was 12,000, and with a promotion campaign over the next five years, the city brought in attractions such as rodeos, dog shows, horse shows, aviation shows, and auto racing. Throughout the 1920s, Beverly Hills went through a building boom all over the city. By the end of the 1920s, the Doyen Greystone estate was one of the last of the great mansions to be built in Beverly Hills, thereby ending an era.

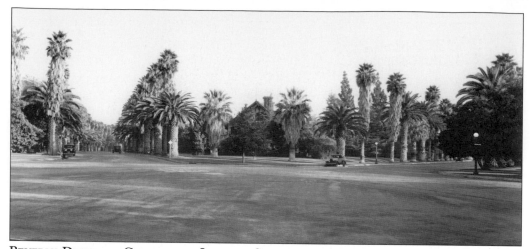

BEVERLY DRIVE AT CANON AND LOMITAS SOUTH, 1931. Before much of Beverly Hills was overgrown with the first landscaping planted in 1906, there were only a few mansions built south of Sunset Boulevard. At the southeast corner of Beverly Drive is one of the early Tudor-style mansions. It was built around 1915 and in the late 1930s was the home of artist and film director Harry Lachman. By 1911, there were only six houses north of Santa Monica Boulevard, some of which belonged to Pierce E. Benedict, William B. Hunnewell, Henry C. Clarke, J. M. Hunter, R. M. Kedzie, and a Mr. Peters. After the opening of the Beverly Hills Hotel in 1912, the first of the great estates were built north of Sunset Boulevard, beginning with that of Henry Winchester Robinson and was followed over the next eight years by Burton E. Green, Max H. Whittier, William B. Joyce, King Gillette, former Kansas congressman W. A. Reeder, Roland P. Bishop, Thomas Thorkildsen, banker Irving Hellman, H. D. Lombard, W. E. Woods, and Silsby M. Spalding (the city's first mayor and son-in-law of Charles Canfield, who died in 1912).

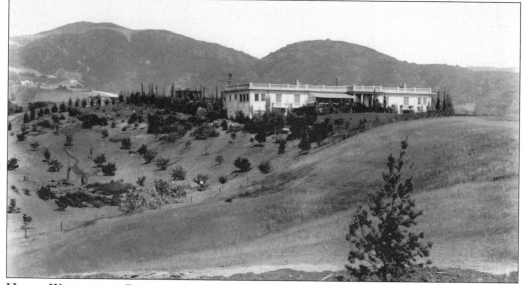

HARRY WINCHESTER ROBINSON ESTATE, 1912. The first estate built north of Sunset Boulevard was that of Harry Winchester Robinson at 1008 Elden Way. When the mansion was built in 1911, the only other homes in the hills above Sunset were hunting lodges. Surrounding the house were botanical gardens planted by Virginia Robinson. Along with the estate, they were donated to the County of Los Angeles as a public park known as the Virginia Robinson Gardens.

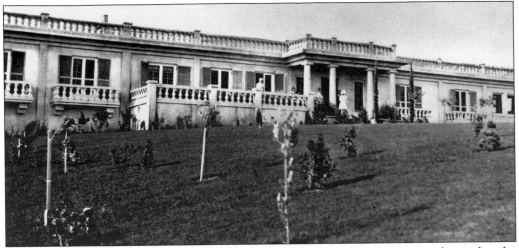

ROBINSON ESTATE, 1912. The original lot contained approximately 15 acres, but today the estate measures around 6. The Classical Revival home and gardens are listed on the National Register of Historic Places. The Robinson Gardens, as they are known today, were built as a wedding present for Harry and Virginia Robinson of the J. W. Robinson department stores. The couple wed in 1903.

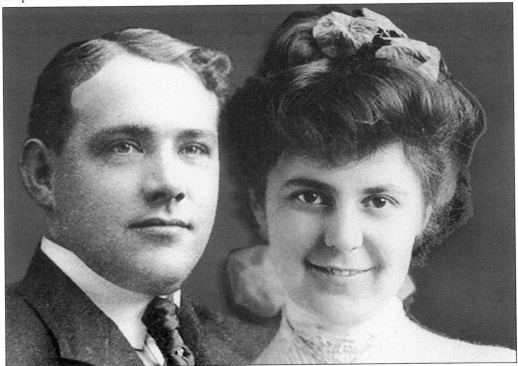

HARRY AND VIRGINIA ROBINSON. Harry Winchester Robinson, of the J. W. Robinsons department stores, married Virginia in 1903. Shortly after the wedding, they left on an extensive honeymoon around the world. While traveling, Virginia became interested in exotic plants and styles of landscaping. After moving into their estate in Beverly Hills, she cultivated her collection of plants from around the world and created one of the best exotic gardens in Southern California.

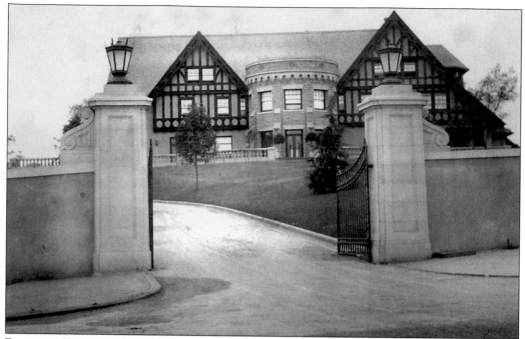

BURTON GREEN ESTATE, 1914. Beverly Hills founder Burton Green built his estate on Lexington Road behind the Beverly Hills Hotel between September 1912 and early 1914, the same year as the incorporation of Beverly Hills as a city. On the lavishly landscaped grounds was one of the first swimming pools in the city.

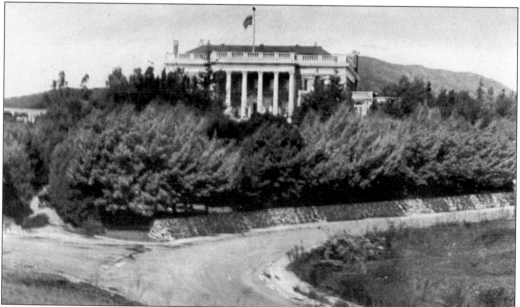

ROLAND P. BISHOP ESTATE. This grand mansion on Hartford Way was later acquired by Los Angeles banker Irving Hellman and became one of Beverly Hills's most important landmarks. Demolished in the 1950s, the property was subdivided into home sites. One of these buyers was actor Glenn Ford, who built his modernly styled home on one of the lots. The stone wall that surrounded the Bishop estate is all that survives today.

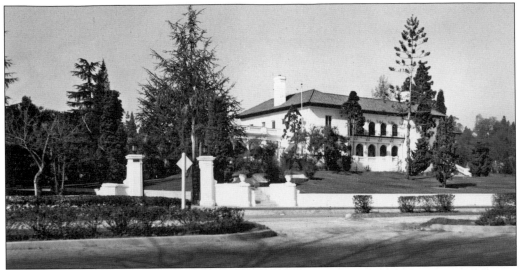

Max Whittier Estate, 1937. Located at 9561 Sunset Boulevard and Alpine Drive the 38-room Italian Renaissance–style mansion was built by oilman and Beverly Hills founder Mercios H. "Max" Whittier in 1916. Built on the site of the Maria Rita Valdez Rancho Rodeo de las Aguas property, the mansion burned in an arson fire in 1980.

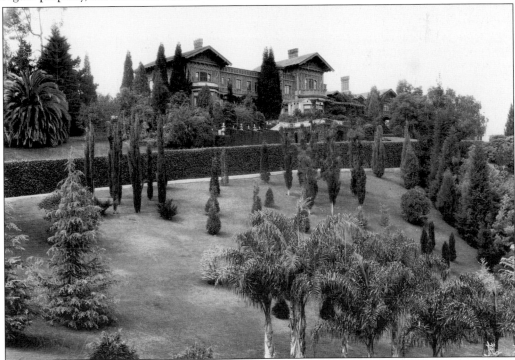

Thomas Thorkildsen Estate, 1926. The Thomas Thorkildsen estate was built overlooking Coldwater Canyon at the end of Crescent Drive in 1912. One of the largest Craftsman-style mansions in California, it occupied approximately 17 acres at the end of Alpine Drive. In 1913, Thomas and his wife, Udora, purchased another 11 acres adjacent to their property. By 1921, the estate was acquired by oilman Kirk B. Johnson, and by the 1930s, it was known as the Keith Estate. By the 1960s, buildings on the estate were demolished, and the property was subdivided.

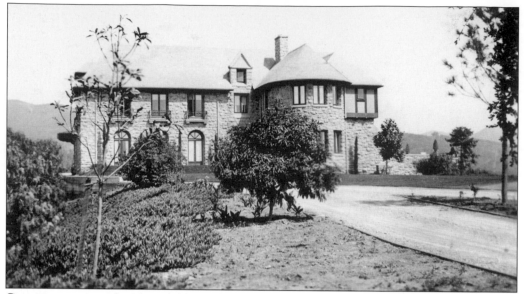

GRAYHALL, 1919. In 1911, Silsby Spalding married the daughter of Beverly Hills pioneer Charles Canfield and began to remodel one of the hillside hunting lodges into an estate. The new estate was named Grayhall and occupied a 54-acre parcel. In 1919, famed film star Douglas Fairbanks rented the mansion while his own hunting lodge nearby was being renovated into a proper house, which later became known as Pickfair.

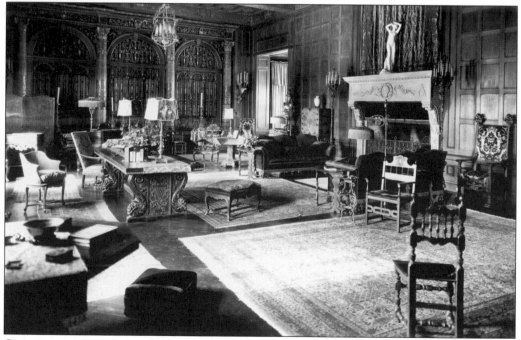

GRAYHALL, 1920. Located at 1100 Carolyn Way, the estate was once a hunting lodge, built by Carole Lombard's father in 1909. After Silsby Spalding remodeled and enlarged the house, it became one of the earliest estates built north of Sunset Boulevard. The ballroom's main attraction was a replica of a 15th-century polychrome ceiling. In more contemporary times, it was owned by actor George Hamilton and investor Bernard Kornfeld.

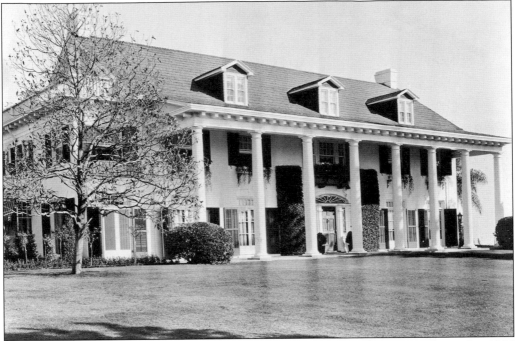

FRANK FLINT ESTATE, 1938. The American Colonial Revival–style mansion, located at 1006 North Crescent Drive, was originally built for Elizabeth Thomas and later owned by Silsby and Caroline Spalding in 1918 and by 1921 H. D. Lombard. Industrialist Frank Flint acquired the estate sometime in the 1930s. The house was among others of the same Southern plantation image that conveyed the emerging elegance of the Beverly Hills lifestyle of the early 1920s.

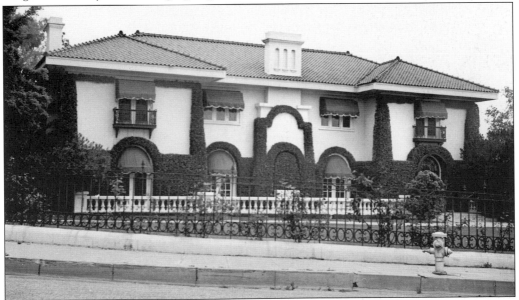

JOYCE ESTATE, 1947. Built by banker William B. Joyce around 1918, the mansion located at 1000 Elden Way, off of Crescent Drive, has been one of the more prominent Beverly Hills landmarks and has been featured in several 1920s Beverly Hills real estate brochures. The Joyce Estate was one of several mansions built north of Sunset Boulevard before 1920.

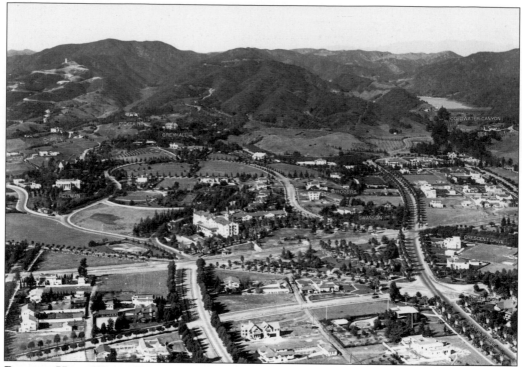

BEVERLY HILLS HOTEL DISTRICT, 1924. The Beverly Hills Hotel was considered the center of residential life in the area, with major estates surrounding in the 1920s, among them Pickfair, Grayhall, the mansions of Gloria Swanson, Will Rogers, Irving Hellman, Charles Chaplin, and Burton Green. Due to the many residents north of Sunset Boulevard that owned their own horses and stables, a plan was put forward when Stanley Anderson, husband of the Beverly Hills Hotel's Margaret Anderson, and banker Irving Hellman organized and incorporated the Bridle Path Association in 1924.

LONGYEAR ESTATE, 1920. One of the early Beverly Hills pioneer residents was Willis D. Longyear. The Longyear estate was at 721 North Beverly Drive, near Sunset Boulevard. With its Green and Green Craftsman design, it became the center of social activities in Beverly Hills for a number of years. Ida Mackay Longyear hosted lunches and teas for the women of Beverly Hills, making the Longyear Estate a cultural landmark.

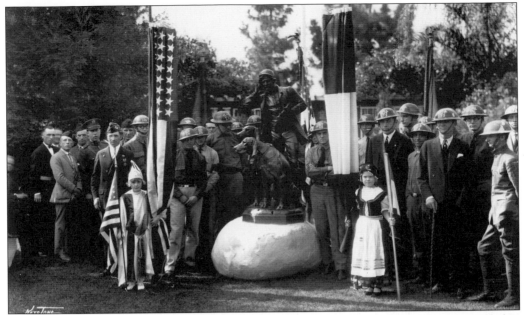

LONGYEAR ESTATE, 1925. The Chateau Thierry statue *Hunter Boy and Hounds* was unveiled in honor of Armistice Day. In 1917, tragedy hit the Longyear family when their son was killed in the battle at Chateau Thierry in France. When Longyear went to France to bring back the body of his son, he noticed a shell-scarred bronze statue of a hunter and hounds that stood near the very spot where his son had been killed. After many years of trying to acquire the statue, it was eventually brought to Beverly Hills and placed on the lawn of the estate. For many years, memorial ceremonies were held on the front lawn honoring the soldiers who died during World War I. The statue was installed in the parkway along Santa Monica Boulevard, where it remains.

BENEDICT CANYON, 1926. Edson A. Benedict gave up his grocery store in downtown Los Angeles in 1868 and filed claim on a property later named Benedict Canyon in the Rodeo de las Aguas Rancho. Edson and his family moved to the mouth of the canyon and built their house. In 1876, Pierce, one of three sons, purchased 230 acres of land further up the canyon and adjoining his father's property and built a house on the site. It later became the estate of Beverly Hills Hotel owner Stanley Anderson.

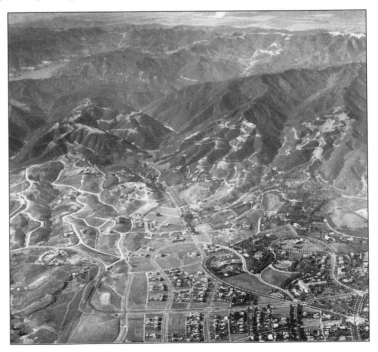

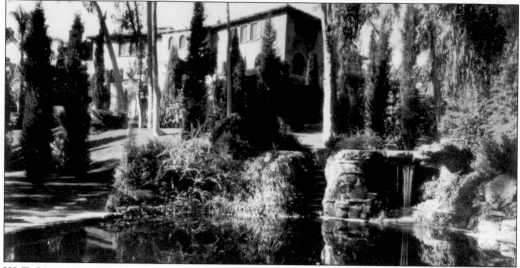

W. F. SCHUYLER ESTATE, 1925. Located off Schuyler Road, near the Doheny Road intersection, the W. F. Schuyler estate was built into the side of a hill, with exotic gardens running south to Doheny Road.

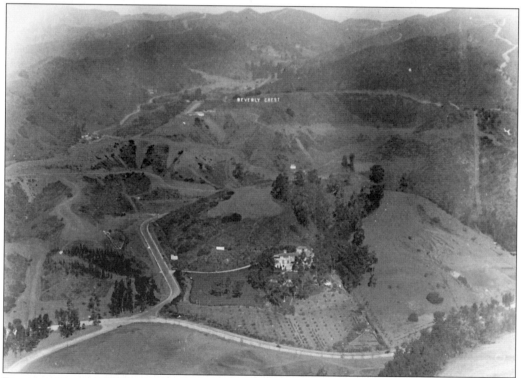

BEVERLY CREST, 1925. Originally known as Wiltfong Canyon, or "Chinaman" canyon, the hillside was developed as Beverly Crest by real estate developer George Read in 1924. In the center is the W. F. Schuyler estate, surrounded by a eucalyptus forest. In 1955, on a hill just above the estate, Lucy Battson, the former Mrs. E. L. Doheny Jr. built her second home there with her second husband, Leigh Battson. They named the estate The Knoll, which was later the home of Kenny Rogers, Dino di Laurentis, and Marvin Davis.

REAL ESTATE AGENT JESSIE V. DUGGAN ADVERTISEMENT. A home in Beverly Hills is priced at $20,000, including a beautifully landscaped garden, games enclosure, a sun room, three bedrooms, two baths upstairs, and a maid's room. The 80-by-156-foot lot featured a nine-room house.

BEVERLY TERRACE TRACT, 1926. Located on the western portion of Benedict Canyon, the Beverly Terrace Tract on the border of Beverly Hills and Los Angeles County was where the Harold Lloyd, Thomas Ince, George Lewis, and Valentino's Falcon Lair estates were built in the 1920s. The principal roads within the tract included Angelo Drive, Bella Drive, Hillgrove, Carolwood, and Tropical Drives.

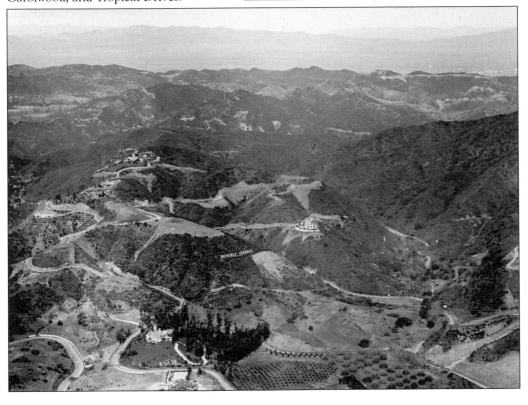

WILLIAM AND LILIORE RAINES ESTATE, 1939. Located at 603 Doheny Drive at Schuyler Road, this estate was built adjacent to a natural forest of fur trees that were fed by underground streams that feed the water system known to history as Rodeo de las Aguas, or "the gathering of the waters". Liliore was one of the daughters of Beverly Hills founder Burton E. Green.

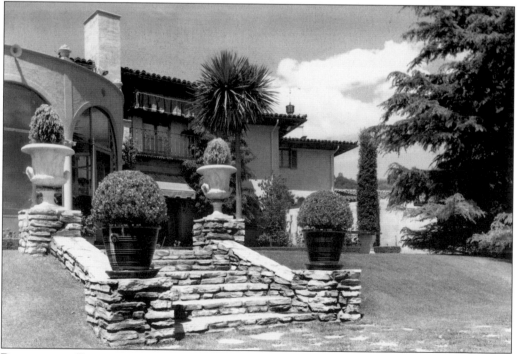

BAYERKNOLL ESTATE, 1933. Located at 630 Doheny Road at the southeastern corner at the intersection of Foothill, the estate dominated the immediate area for over 40 years before it was torn down and subdivided.

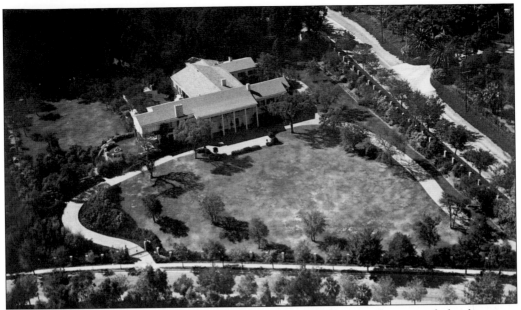

E. L. CORD ESTATE, 1934. In 1931, Eric Lobban Cord, manufacturer of the luxurious Duesenberg and Cord automobiles, built a mansion on his 10-acre North Hillcrest Road estate, above Sunset Boulevard. The 30-room, Colonial-style mansion at 811 North Hillcrest Drive was designed by architect Paul R. Williams and was framed across its wide front by a Colonial Revival portico. The Cord estate across the street from the Doheny Ranch was demolished and subdivided in 1962.

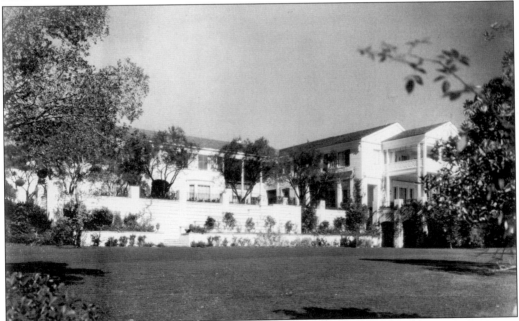

CORD ESTATE, 1932. The Cord mansion was a two-story, five-pillared, 87-room, main house that had 36,000 square feet of living space. The interior included Chippendale furniture, walls of mahogany, and drapes of blue satin, with white marble floors. There was a formal ballroom, crystal chandeliers, and a curved marble staircase.

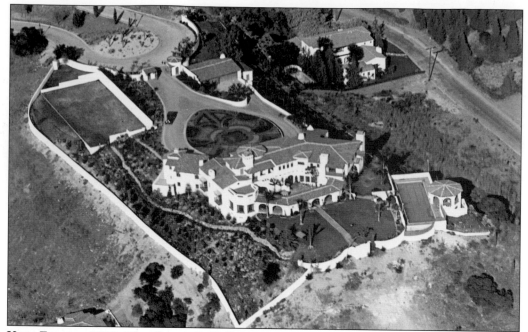

KOLB ESTATE, 1933. The George O. Kolb Estate was located at 1146 Tower Road and was one of the best examples of 1920s Spanish-Mediterranean architecture. Businessman Kolb's estate included a tennis court, swimming pool, circular driveway, and a massive mansion with gardens, arched atriums, and a view of the city that was second to none. Kolb was a member of the park commission and other civic organizations in Beverly Hills.

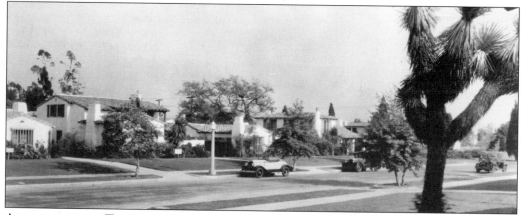

ARCHITECTURAL TRACT, 1929. South of Sunset Boulevard, there were still empty lots at the end of the 1920s. Several developers and their architects concentrated their work in several areas, such as Arden and Maple Drives, where there were clusters of Spanish-style homes by such architects as Harry Werner, Garrett Van Pelt, Paul Williams, Koerner and Gage, and Wallace Neff. In 1906, Wilbur Cook, the designer of the master plan of Beverly Hills was one of America's foremost landscape architects and community planners. Cook laid out lots north of Santa Monica Boulevard for upper-middle-class and well-to-do families. He divided the strip of land between Santa Monica and Sunset Boulevards into four blocks, with the lots on each block generally getting larger and more expensive as they neared Sunset Boulevard and the hills. The rolling land above Sunset Boulevard was reserved for large mansions, nestled among the foothills or perched on knolls along winding roads.

Five

GREYSTONE
1928–1940

In March 1926, oilman Edward Laurence Doheny Sr. and his wife, Estelle, granted a deed of ownership to Edward's son Ned Doheny for 12.58 acres of their 429-acre parcel of land in Beverly Hills, known as the Doheny Ranch. They intended to sell it to Ned and Lucy Doheny for the sum of $10, as a wedding gift. Construction began on February 15, 1927 and was completed on September 24, 1928, at a cost of $3,135,563.63.

At the end of September 1928, Ned Doheny and his wife, Lucy Smith Doheny, and their four sons and one daughter moved into the new estate. Almost immediately, the estate, named Greystone, became the most prominent landmark in the area. The exterior architecture is of a Baronial style consisting of Indiana limestone, Welsh slate, and leaded glass windows. The interior was 18th-century English in style, with carved wood paneling and marble floors. Greystone is 46,054 square feet, with 55 livable rooms (67 in all). The estate had on its grounds a stable area, tennis courts, greenhouses, kennels, and swimming pool. The landscaping included a waterfall, small golf course, playhouse, and beautiful gardens (both formal and informal).

Tragedy struck the Doheny family on February 16, 1929, when Ned Doheny was shot and killed by his personal secretary, Hugh Plunkett, who in turn killed himself nearby. After Ned's death, Lucy Doheny lived in the house with the children and remarried oilman Leigh Battson in 1932. They remained on the property until 1955.

In 1954, Lucy sold the Doheny Ranch property to developer Paul Trousdale, who developed the Trousdale Estates housing tract. In 1955, the house and grounds were sold to Chicago industrialist Henry Crown for a reported $1.5 million. Crown and his Park-Grey Corporation held on to the estate as an investment and rented it out to movie companies for location filmmaking. Between 1964 and 1965, the City of Beverly Hills negotiated with Henry Crown to purchase Greystone and its grounds to build a 19.3-million-gallon subsurface reservoir. In 1965, the city finally purchased the entire mansion and grounds for $1.3 million. From 1965 to 1969, there was nothing happening at the property while film companies continued to film at the estate. In 1969, the American Film Institute leased Greystone for the site of an advanced film school until they vacated in 1982. It was during this time, on September 16, 1971, that the City of Beverly Hills formally dedicated Greystone as a city park. On April 23, 1976, Greystone was added to the Department of the Interior's National Register of Historic Places.

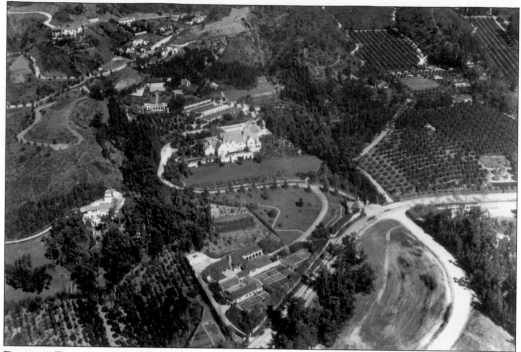

DOHENY ESTATE, 1933. The Doheny Estate consisted of the 429-acre Doheny Ranch on the eastern portion of the property, with citrus groves, a ranch house, and bridle paths. Greystone Mansion, built on 12.58 acres, included stables, gardens, waterfall, kennels, and a small golf course, all completed by June 1928. On the left portion of the photograph can be seen the William Schuyler Estate and Schuyler Road in the Beverly Crest development northwest of Greystone.

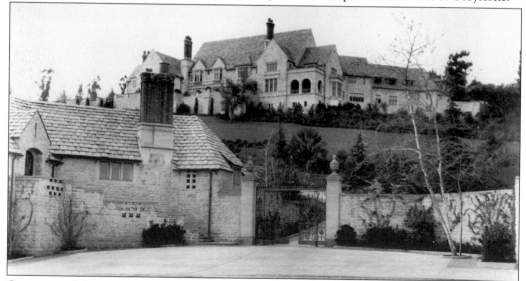

GREYSTONE MANSION, 1928. The mansion was built of Indiana limestone with a grey, Welsh, slate roof consisting of 55 livable rooms—67 in all, with a commanding view of the city below. The gatehouse on Doheny Road seen in the foreground of the photograph is a miniature version of the mansion, with wrought-iron gates and a driveway leading up to the mansion's courtyard and entrance door.

GREYSTONE MANSION, 1928.
The mansion's style is Baronial with French Gothic and Paladium architectural elements as well as leaded glass windows, lead rain gutters, and ornamental brick chimney stacks. Built of steel reinforced concrete including the roof, "the house would last a thousand years." This view is of the southern side of the mansion, with patio and glass entrance doors into the great hall.

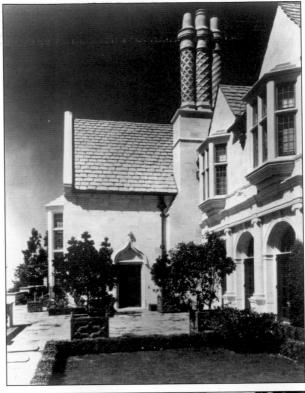

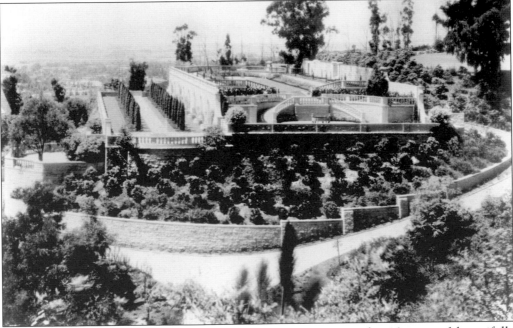

ESTATE GARDENS, 1928. Behind the Greystone mansion are the 16 acres of beautifully landscaped, formal and informal gardens. They are terraced into the hill, with walkways and stairs leading from one area to another. Adjacent to the gardens are the swimming pool, badminton courts, the small golf course, the guest/playhouse, and waterfalls.

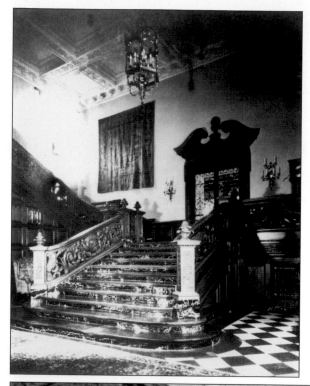

GREYSTONE MANSION, 1928. The grand staircase in the great hall of the mansion was made of hand-carved wood and marble that led into the hall of checkerboard marble flooring and wood paneling throughout. The 18th-century-style, Baronial house was built on a smaller scale than East Coast mansions, designed to have the feel of grandeur but the practicality of being a modest home.

GREAT HALL, 1929. The great hall of Greystone was elegantly appointed, with just a few pieces of furniture and massive oriental carpets that gave the interior a warm feeling of being a home, not a palace. The arched entryway separating the grand staircase from the hallway was made of hand-carved wood paneling, and the ceiling was made of ornate pressed plaster.

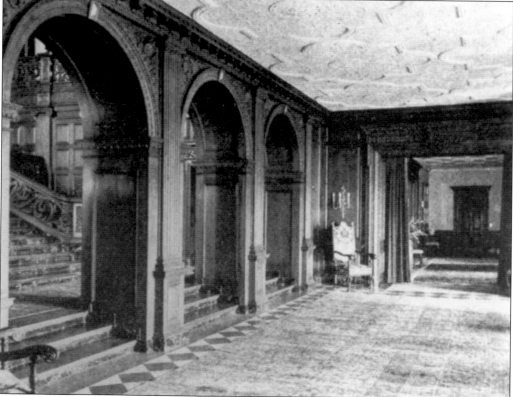

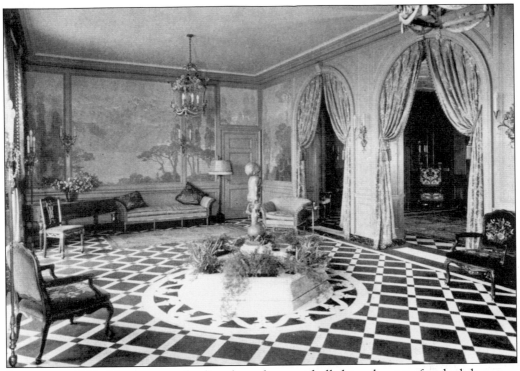

SUNROOM, 1929. The sunroom leading from the great hall through a set of arched doorways leads out onto a large patio area overlooking the lower grounds, driveway, and front gate of the estate. The sunroom, with its marble patterned floor and central fountain, was one of the most delightful rooms in the entire mansion where guests could mingle.

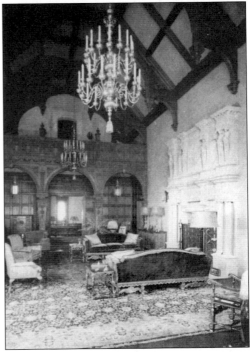

GRAND LIVING ROOM, 1929. The grand living room at Greystone was designed in the Gothic style, with a vaulted ceiling, large fireplace, wood paneling, an arched entrance, leaded glass windows, and a minstrel loft completed with Georgian style chandeliers that the room an "old world" feeling. There are secret cabinet doors in the wood paneling at the entrance to the room, which also interconnects with the sunroom and the patio outdoors.

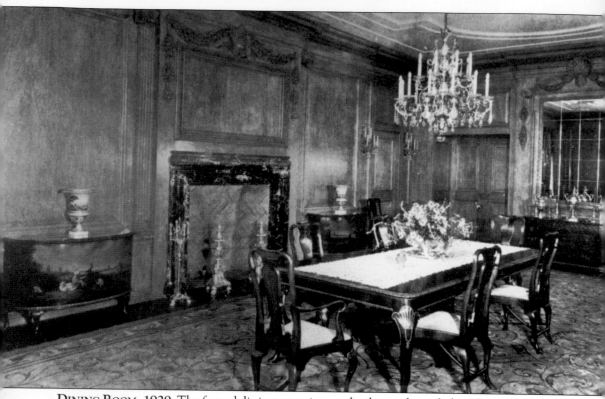

DINING ROOM, 1929. The formal dining room is completely wood paneled, with marble flooring and fireplace surround. With its low ceiling and intimate proportions, the room is more personal and livable than what might be expected from a grand mansion like Greystone. All the rooms in the mansion are smaller in dimension, creating the illusion of the "mansion" as a house where a family could comfortably live. There were fireplaces on both sides of the room and a carved wood mirror and painting frames inlaid into the wood paneling. One window and two glass doors lead onto the outer patio, and southern light illuminates the room most of the day. When the American Film Institute was using the estate as a film school for advanced students, a grant program video- and audio-taped oral histories of important motion picture personalities here. The formal dining room was equipped with special lighting and sound apparatus to record the interviews, which are archived at the American Film Institute Library.

Six

THE GARDEN CITY
1912–1940

When the master plan for the City of Beverly Hills was originally conceived, the planners had in mind a park-like environment for the area. The planning and landscaping of the hills north of Sunset Boulevard were supervised by the Olmsted Brothers, landscape artists who worked from a blueprint designed by community planner Wilbur David Cook Jr. The gently curving streets, extra-spacious home sites, and generous setbacks for the landscaping were to help promote this city as a special place to live. By 1915, a new park was constructed south of Sunset Boulevard by the Beverly Hills Hotel Company. The terraced triangle of flower gardens, a fountain, pools, and shady walkways were originally landscaped as part of the hotel grounds, but later were given to the city by the Anderson family and renamed Sunset Park. Shortly thereafter, with many potential real estate buyers arriving at the Pacific Electric Depot at Canon Drive and Santa Monica Boulevard, first impressions of the new development were important. As a sales promotion, a park was installed on a three-block stretch along Santa Monica Boulevard named "Beverly Gardens," later known as Park Way. Its grassy areas, trees, and other special plantings were highlighted by a massive lily pond and fountain with a large, arched sign surrounded with vines and flowers over it that read "Beverly Hills."

With the development of the city streets came the landscaping, at first with palm trees and later many types of trees, after which some of the streets were named. When the Bridle Path was constructed in 1924, a pathway was created in the center of Sunset Boulevard, surfaced with decomposed granite with a hedge of flowering shrubs that was planted on both sides of its entire length. The bridle trail was extended down Rodeo Drive and up Benedict Canyon Drive, where it connected with many trails and paths in the mountains overlooking the city. With the influx of people building homes, landscaping their properties became a major industry in the city. The famous Beverly Hills Nursery, located at the triangle point of where Santa Monica and Wilshire Boulevards meet (now the site of the Beverly Hilton Hotel), supplied a majority of the plantings for the entire area, well into the 1950s.

BEVERLY GARDENS, 1939. Park Way (Beverly Gardens) originally consisted of a three-block stretch along Santa Monica Boulevard from Crescent to Rodeo Drives. The central park where the lily pond was located is situated between Beverly Drive and Canon Drive. On the southeast corner stood the Beverly Rail Station, which was the most prominent landmark in Beverly Hills since 1896 until it was demolished to make way for the post office building in 1934.

BEVERLY DRIVE, 1928. Here on Beverly Drive looking north, two types of palm trees were planted in 1907 in an alternate pattern on the curved streets, giving the visitor and resident alike the sense of living in a park. Starting in 1927, Beverly Hills entered a flower-designed float in the Tournament of Roses Parade in Pasadena and won top honors. The awards brought tremendous publicity to the city. The next year, Beverly Hills won yet another top award, making it the first time in tournament history that both prizes were won in successive years by any city.

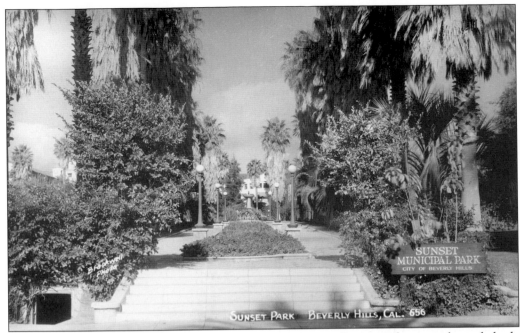

SUNSET MUNICIPAL PARK, 1931. The terraced triangle of flower gardens, ponds, and shady walkways across Sunset Boulevard was originally landscaped as a part of the Beverly Hills Hotel grounds when it was installed in 1912. It was one of the two parks in the city until 1915, when it was officially given to the city by the Andersons, the hotel owners. In 1952, the park was renamed Will Rogers Memorial Park in honor of one of Beverly Hills's most beloved resident, Will Rogers.

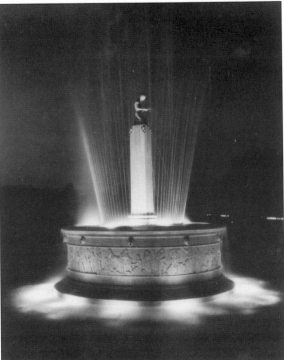

WILSHIRE ELECTRIC FOUNTAIN, 1931. The crowning jewel of fountains was erected at a cost of $22,000 in 1931 and designed with ever-changing combinations of water jets and colored lights. The fountain was installed thanks to the fund-raising activities of homeowners spearheaded by Harold Lloyd's mother. Designed by architect Ralph Feeling and adorned with a bas-relief by Merrell Gage, the fountain became known for its beautiful lighting effects in jets of water. The bas-relief depicts a Gabrielino Indian's rain prayer, and the frieze around the fountain depicts the rich history of California.

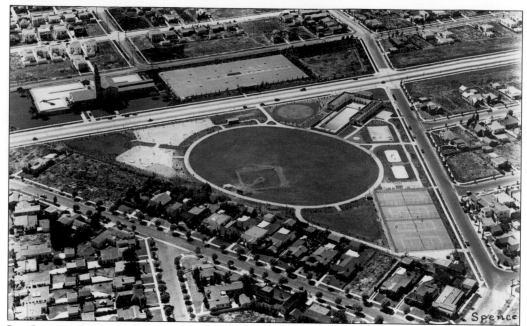

LA CIENEGA PARK, 1930. La Cienega Boulevard intersects the 10-acre La Cienega Park on the eastern border of Beverly Hills. Established in 1928, the park included a baseball diamond, tennis courts, lawn bowling, croquet, horseshoe pitch, gymnasium bars, golf-putting green, children's swings, and the swimming pavilion that was added in 1929. Across the street is the Beverly Hills Water Treatment Plant and reservoir, built in 1927 to soften the water supply for the city and to filter impurities.

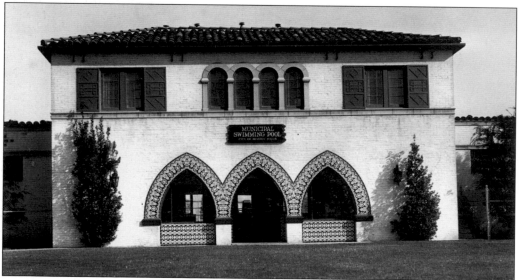

MUNICIPAL SWIMMING POOL, 1938. The entrance to the swimming pool was on the southeast corner of La Cienega and Gregory Way. Opened in 1929, the pool was one of the best swimming facilities in the Los Angeles area. With its Italian Renaissance design, the swim pavilion was 150 by 45 feet and was a landmark in the city until it was demolished in the 1970s. In 1935, a major magazine said that the "Municipal Pool in Beverly Hills La Cienega Park is a luxury rather than a necessity, for the 'Hometown of the movies' has the most equable of climates."

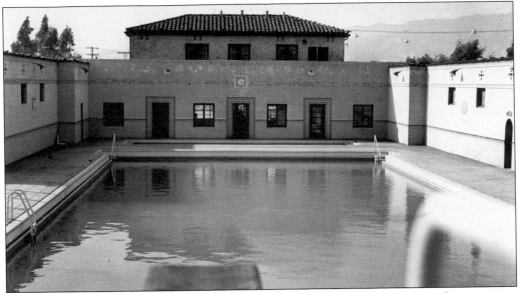

POOL, 1938. The pool area inside the pavilion included offices, dressing rooms, shower rooms, and storage and maintenance facilities. The swim pavilion also had a children's pool that was 2½ feet deep and located between the large pool and the offices. In 1935, a magazine writer said that the "Municipal Pool in Beverly Hills's La Cienega Park is a luxury rather than a necessity."

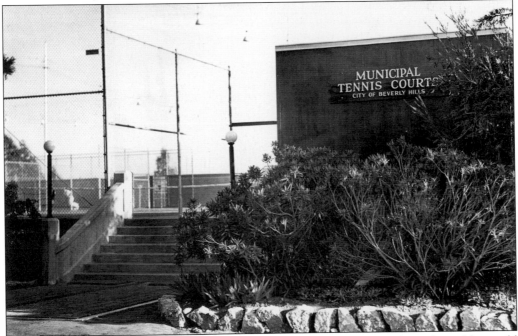

MUNICIPAL TENNIS COURTS, 1938. Beverly Hills had several places where the public could go to play tennis. The courts pictured here were known as the "Reservoir Courts" because they were built over one of Beverly Hills's water reservoirs and adjacent to the Beverly Hills Water Treatment Plant. Located on the southwest corner of La Cienega and Gregory Way, these courts became famous when many national and international tennis tournaments were held there for over 30 years.

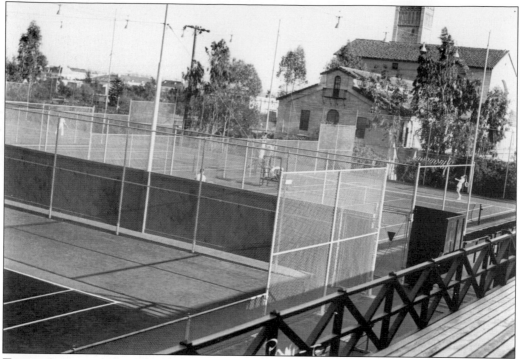

TENNIS COURTS, 1938. Raised above the water reservoir, the courts were extremely popular for decades and were used by Beverly Hills residents and nonresidents alike. After the reservoir and tennis courts were removed, a parking structure was built and the tennis courts were returned to their original site, where they are still as popular as ever. Adjacent to the courts is the Beverly Hills Water Works building, which was renovated and remodeled into the Academy of Motion Picture Arts and Sciences Library.

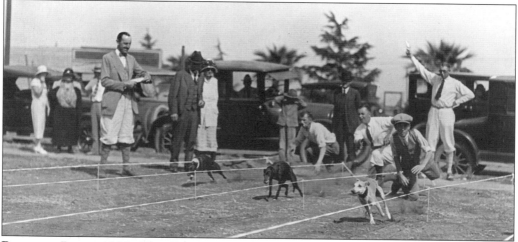

ROXBURY PARK, 1927. The Whippet races at Roxbury Park were usually held annually, continuing a tradition of sports and cultural events that attracted thousands of people to Beverly Hills since the auto racing and horse shows of the early 1920s. Roxbury Park is the largest park in the city, measuring 15 acres, including grassy open spaces, tennis courts, playing fields, and lawn bowling. Located at Roxbury and Olympic Boulevards, the park is not far away from Beverly Hills High School and Century City.

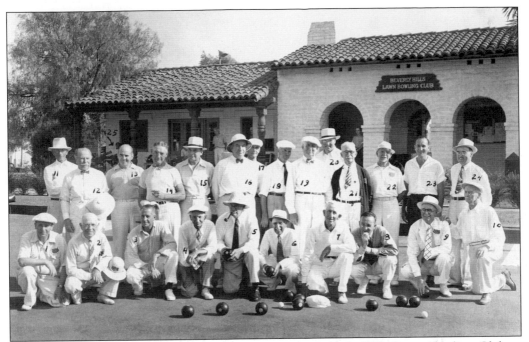

ROXBURY PARK, 1938. Pictured are members of the Beverly Hills Lawn Bowling Club at Roxbury Park. The Lawn Bowling Club was founded in 1926 in the business district and later moved to Roxbury Park. A clubhouse built in the 1930s is where the members socialized and played their game. Walt Disney was one of the early benefactors of the club and bowled at Roxbury into the 1950s. In his honor, one of the many competitive games held annually is the Walt Disney Masters Singles.

ROXBURY PARK, 1936. Universal stars Otto Kruger and Edward Arnold are pictured bowling on the green at Roxbury Park during a tournament. Otto Kruger was starring in *Dracula's Daughter*, and Edward Arnold was starring in *Sutter's Gold*. Both men were members of the Beverly Hills Bowling Club and were followed to Beverly Hills by the Universal publicity department.

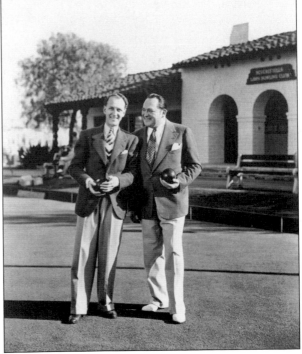

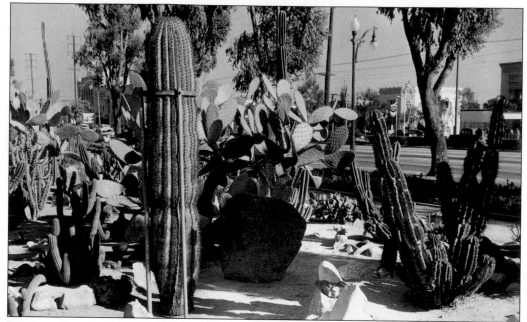

BEVERLY GARDENS–PARK WAY, 1948. Beverly Gardens is the strip of parkland that extends from one Beverly Hills border to the other, running between Bedford and Camden Drives. A section of the strip was segregated as a cactus garden, composed of one of the finest collections of cactus in Southern California. The park, extending 23 blocks, spanned the entire two-mile length of Beverly Hills. Through the center ran a 10-foot-wide promenade bordered with weeping evergreen elms, beds of rare flowers, rose gardens, cactus beds, benches, pergolas, and lily ponds.

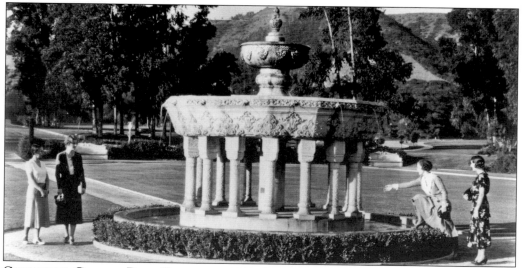

COLDWATER CANYON PARK FOUNTAIN, 1932. Located in the three-acre park at the junction of Coldwater Canyon and Franklin Canyon Drive, a plaque dedicates the park at the "gathering of the waters" or Rodeo de las Aguas, the original namesake for the rancho lands of modern day Beverly Hills. The magnificent, tiered fountain was installed in 1923 and stood more than 11 feet tall. It was removed around 1960, when the Los Angeles Country Flood Control District installed a storm drain and catch basin nearby.

Seven

REAL ESTATE BOOM
1920–1929

Between 1914 and 1920, development of the new city of Beverly Hills was slow but steady. From 1920 to 1925, the population grew from less than 700 people to 7,500. By 1926, it was up to 12,000. Business lots were priced at around $800, and six years later prices rose to $70,000. Throughout the 1920s, Beverly Hills developed a reputation as a gathering place with rodeos, horse, dog and flower shows. In 1921, a one-and-a-quarter-mile, wooden, oval automobile racetrack was built south of Wilshire Boulevard and west of Beverly Drive as a promotion to create publicity for the city. By 1924, the track was removed to Culver City to make way for further expansion of development during the Beverly Hills boom. During this time, major residential development was underway north and south of Sunset Boulevard with the construction of houses, businesses, and city infrastructure. With this influx of people, the city's needs increased with demands for schools, churches, and more parks. Streets were paved, widened, extended, and lighted. By 1928, the Beverly Wilshire Hotel, the Beverly Theater, and other major buildings became landmarks on Wilshire Boulevard. Two bond issues of 1923 and 1924 provided money for additions to the original Hawthorne School and the construction of an additional elementary school in the city limits. In 1925, Beverly Vista School on South Elm Drive was dedicated. El Rodeo School on Whittier Drive opened in 1927.

The work of several Beverly Hills movie celebrities helped save Beverly Hills's independence and stopped any Los Angeles annexation movements in 1923. As the young city's numbers continued to grow, water became a major concern. There was a plan to turn over to the City of Los Angeles the city's water system and apply for annexation. The city sued to enforce its contract, while the company, through petitioning, was able to force a special election. Beverly Hills voters went to the polls to stay an independent city. The leaders of the anti-annexation group were backed by such movie personages as Will Rogers, Mary Pickford, Douglas Fairbanks, Harold Lloyd, Tom Mix, and Rudolph Valentino. On April 24, 1923, there were 507 to 337 votes for independence, and the City of Beverly Hills was saved from annexation to Los Angeles.

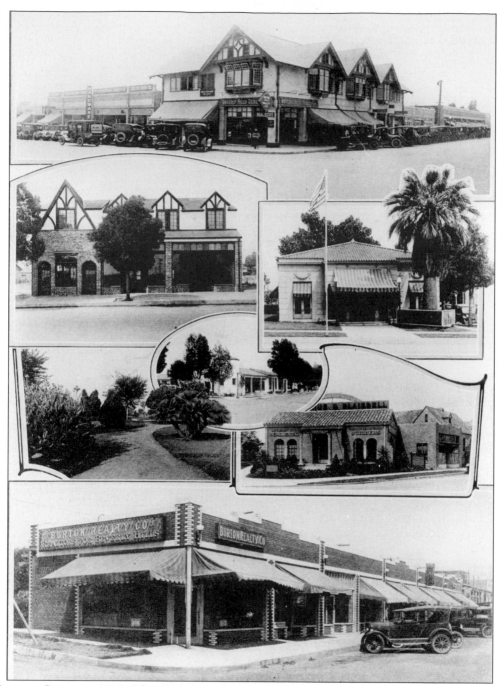

REALTY OFFICES, 1923. The 1920s brought a real estate boom to Beverly Hills. In a brochure of 1922, the business district was described as follows: "The substantial business buildings are modern in plan and attractive in architectural design." The most important of the first business buildings was the Peck Building, built in 1907 by C. L. Peck at the southwest corner of Burton Way (South Santa Monica Boulevard today) and Beverly Drive (top photograph). By 1915, other real estate agents were helping to sell property, and they continued to do so well into the 1920s.

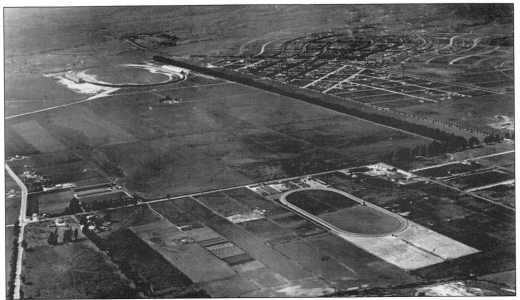

AERIAL PHOTOGRAPH, 1922. This view looks northwest from Robertson Boulevard, with Pico at the left and Wilshire Boulevard on the right. In the foreground is the Beverly Hills Riding Academy ring at Doheny Drive, and at top left is the Beverly Hills Speedway, located at Beverly Drive and Wilshire Boulevard. Below left is the old Hammel and Denker Ranch at Pico and Robertson Boulevard.

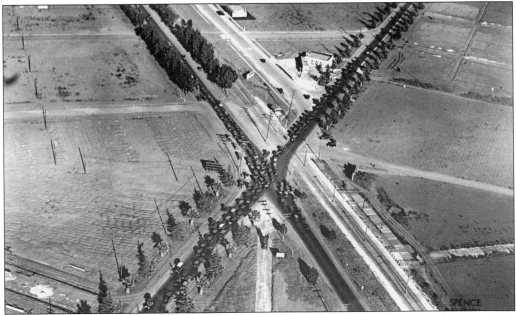

SANTA MONICA AND WILSHIRE BOULEVARD, 1924. The Beverly Hills Automobile Club staged a traffic jam at the intersection of Wilshire and Santa Monica Boulevards to demonstrate the need for traffic signals on Beverly Hills streets. The jam-up was held on a Sunday in 1924. At this time, Beverly Hills was still in the process of development. The area around this intersection was still open land until 1928. Today the triangle at the bottom of the photograph is the site of the Beverly Hilton Hotel.

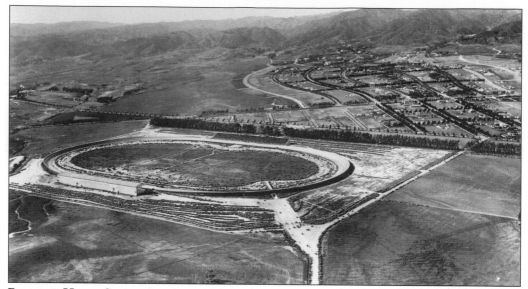

BEVERLY HILLS SPEEDWAY, 1922. Located at Beverly Drive and Wilshire Boulevard, the Speedway was constructed by the Speedway Association, comprising, among others, Silsbee Spalding, Cliff Durant, and Jake Dansinger. The Speedway tract measured 193 acres where the wooden board track was built in 1921 on Wilshire Boulevard and Beverly Drive. For several years, the greatest names in motor racing appeared at the Speedway. The stadium was also used by the Beverly Hills Horse Show, the flower show, and other events that brought thousands to Beverly Hills. The Speedway was demolished after the Washington Day race in 1924, and the tract was purchased for development.

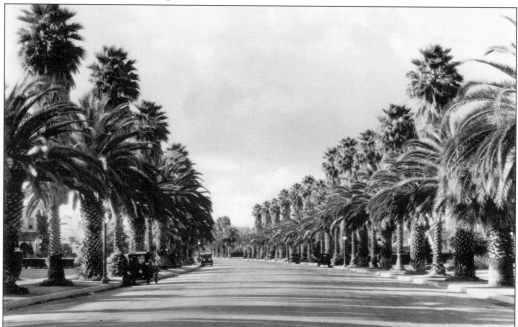

BEVERLY DRIVE, 1922. Looking north along the curved palm-tree-lined street, the original master plan was to plant different palm types and heights in a staggered pattern to give the area a sense of artistic landscaping and further the idea of the residents living in a park-like atmosphere.

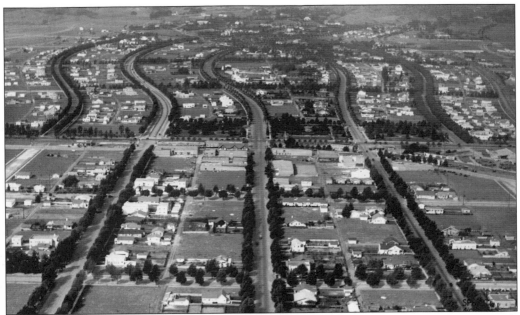

BEVERLY HILLS NORTH OF SANTA MONICA BOULEVARD, 1924. By the mid-1920s, Beverly Hills was still only half developed, with its small business district being centered at Burton Way (South Santa Monica Boulevard today) between Beverly Drive and Canon Drives. Rodeo Drive (the second street from the left in this photograph), Beverly Drive, and Canon, all south of Santa Monica Boulevard, were still residential. In 1924, the Church of the Good Shepard, with its landmark twin golden domes, was erected at Santa Monica Boulevard and Bedford Drive. The Beverly Hills Community Church was organized in 1921, and a church was opened in 1926 at Rodeo Drive and Santa Monica Boulevard.

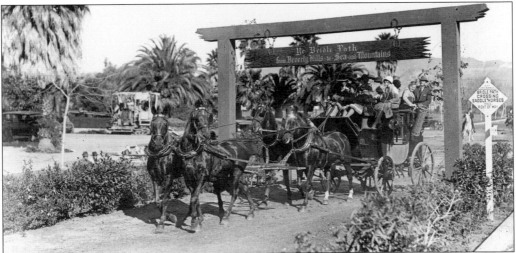

BEVERLY HILLS BRIDLE PATH, 1925. With Irving H. Hellman as president, the Bridle Path Association was formed in 1923 to create bridle paths on Sunset Boulevard, Benedict Canyon, Coldwater Canyon, and down Rodeo Drive. A Pacific Electric trolley ran up Rodeo and along Sunset for a time. The line existed for a few years, before it was abandoned due to lack of passengers. In 1923, the rail right-of-way was purchased by the Bridle Path Association and a bridle path as installed.

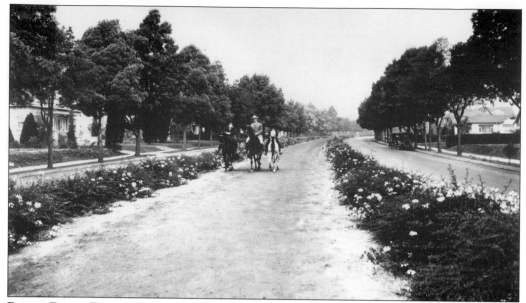

RODEO DRIVE BRIDLE PATH, 1925. Irving Hellman president of the Bridle Path Association is pictured here while riding with his family on the Rodeo Drive Bridle Path, which opened with the first-annual equestrian pageant of Beverly Hills on January 10, 1925. Other financial contributors to the Bridle Path included C. M Spalding, Allen Russell, Douglas Fairbanks, Hobart Bosworth, Charles Munroe, Earl Sandusky, Samuel Kramer, and Charles Blair.

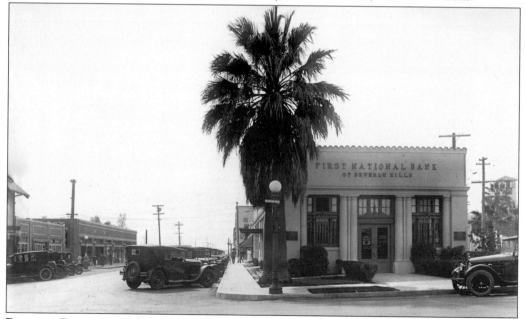

BEVERLY DRIVE AND BURTON WAY WEST, 1925. The First National Bank was Beverly Hills's first bank at the time of the city's founding and was formed by a group of prominent businessmen, including oilman Kirk Johnson, Beverly Hills Hotel owner Stanley Anderson, Sidney Rowe, Pierce E. Benedict, W. A. Reeder, and Albert Hitchen. Across the street, on South Santa Monica Boulevard, was the Peck Building, the first commercial building and first real estate office in the city, established in 1907.

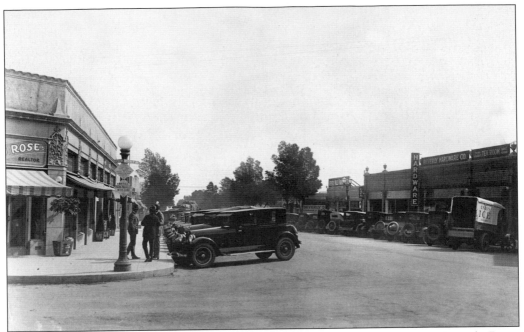

BEVERLY DRIVE AND BURTON WAY, 1925. This photograph looks south on Beverly Drive at Burton Way (later renamed South Santa Monica Boulevard), where some of the first stores established in Beverly Hills made up the commercial district, including Beverly Hills Furniture Company, Beverly Hardware (established in 1912), and the Beverly Hills Tea Room.

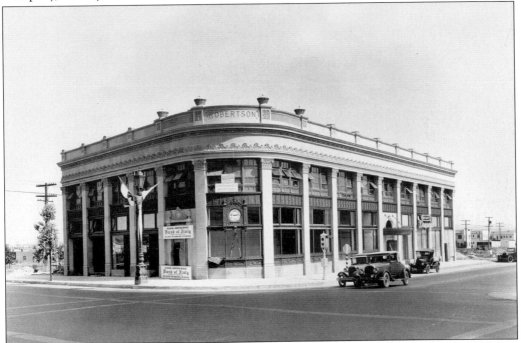

ROBERTSON AND WILSHIRE BOULEVARD, 1927. Located on the southeast corner of Wilshire and Robertson Boulevards was the second Beverly Hills branch of the Bank of Italy (later the Bank of America), which opened in February 1927.

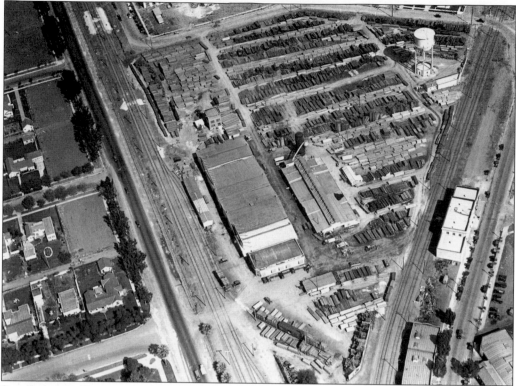

SUN LUMBER COMPANY, 1925. In the industrial triangle at the intersection of Santa Monica Boulevard and what is now Burton Way were the Sun Lumber Company yards. The huge lumber yard supplied building materials for all the construction in Beverly Hills and West Hollywood, only a short distance to the east since around 1921.

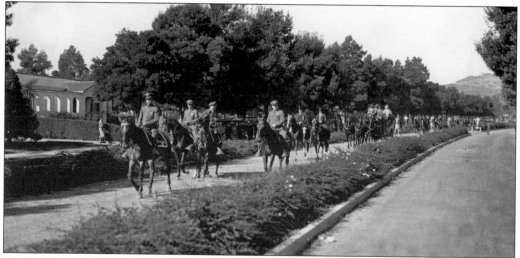

RODEO DRIVE BRIDLE PATH, 1925. The first-annual equestrian pageant of Beverly Hills was held on Saturday, January 10, 1925, marking the celebration of the opening of the Bridle Path of Beverly Hills. The day's program included a parade down the bridle paths of Sunset Boulevard and Rodeo Drive and was followed by a horse show before a grand stand in front of the Beverly Hills Hotel.

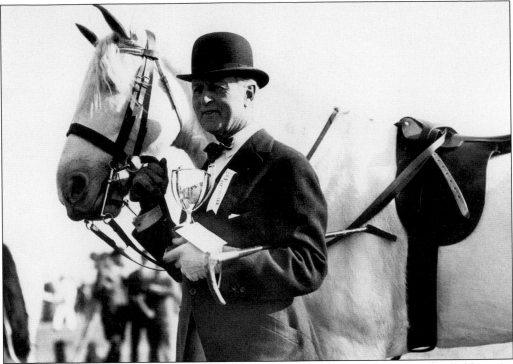

HORSE SHOW, 1925. Famed actor and Beverly Hills celebrity Hobart Bosworth is holding the silver trophy for participation in the first-annual Beverly Hills Equestrian Pageant and the opening of the Beverly Hills Bridle Path. The opening-day celebrations were held January 10th. Some of the other participants included Douglas Fairbanks, Mary Pickford, Irving Hellman (president), Stanley S. Anderson (Beverly Hills Hotel owner), Cecilia DeMille, Mr. and Mrs. C. E. Toberman (Hollywood developer), Mr. and Mrs. Silsby Spalding (first mayor of Beverly Hills), and Mr. and Mrs. Alphonzo Bell (Bel Air developer).

BEVERLY HILLS WOMEN'S CLUB, 1925. Located at the southwest corner of Benedict Canyon and Chevy Chase in Benedict Canyon, the clubhouse was constructed with funds raised in part from the first Beverly Hills Horse Show and the opening of the bridle path. The Women's Club was first formed in October 1916, and the object of the club was to advance all ways of building up community spirit and promoting the general culture and social service. During World War I, the club became a Red Cross unit. By 1925, with donations of $4,000, they were able to buy land and begin construction of the clubhouse. The formal opening of the future Beverly Hills landmark was in October 1925.

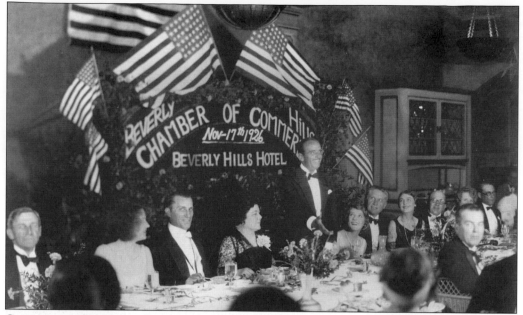

CHAMBER OF COMMERCE DINNER, 1926. On November 17, 1926, the Beverly Hills Chamber of Commerce honored Beverly Hills residents Douglas Fairbanks and Mary Pickford. The Beverly Hills Chamber of Commerce was organized and incorporated in 1923. Before it moved into a new building in 1929, chamber meetings and events were held at the Beverly Hills Hotel. The more prominent celebrities in the group pictured here are, from left to right, Douglas Fairbanks, Mary Pickford, Fred Niblo, and A. C. Heegaard, president of the chamber.

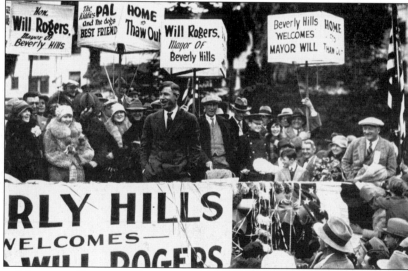

HONORARY MAYOR OF BEVERLY HILLS, 1926. Beverly Hills Hotel owner Stanley S. Anderson suggested that the city appoint Will Rogers as honorary mayor on December 21, 1926. Rogers was one of Beverly Hills's most famous residents since 1921. There was a ceremony in front of the Beverly Hills Hotel, with Beverly Hills trustee president Silsby Spalding presenting Rogers to the crowd that included such notables as actors Tom Mix, William S. Hart, Douglas Fairbanks, and Mary Pickford. In 1927, the California Legislature amended the Municipal Corporations Act so that the trustees were known as councilmen, and the president as mayor.

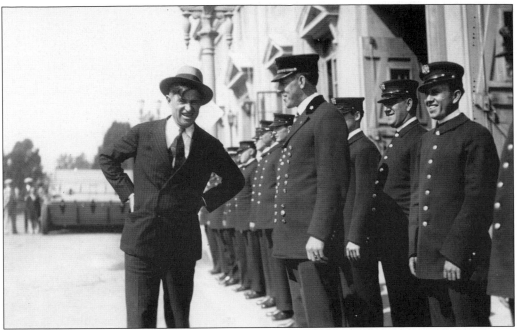

HONORARY MAYOR WILL ROGERS, 1926. Will Rogers, acting as mayor of Beverly Hills, visits the Beverly Hills Fire Department in the newly built city hall complex that housed the police department as well.

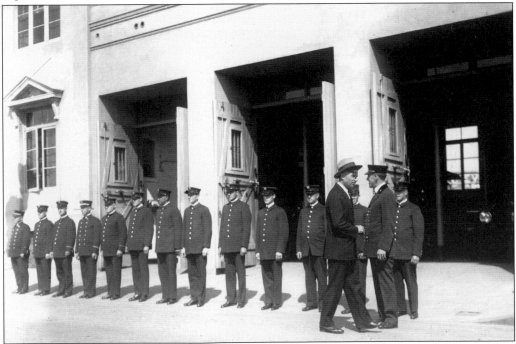

FIRE DEPARTMENT AT NEW CITY HALL, 1926. Mayor Will Rogers inspects fire department personnel at the new city hall. Dedicated in early 1925, the new Beverly Hills City Hall building, located at Crescent Drive and Burton Way, housed city offices, police, and fire departments as well as other city services.

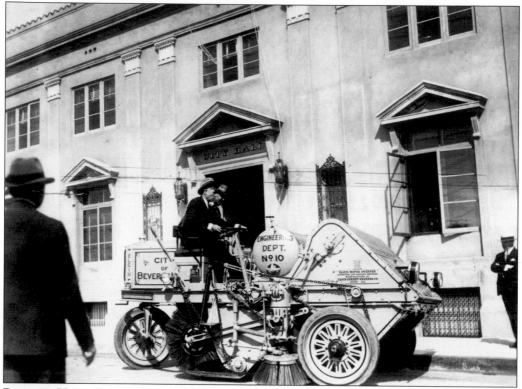

BEVERLY HILLS CITY HALL, 1926. Beverly Hills mayor Will Rogers tries out the city's new street-sweeper machine in front of the new city hall building.

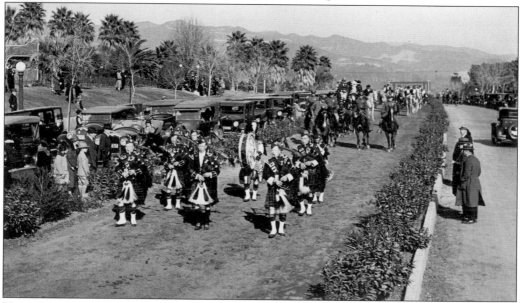

HORSE SHOW PARADE, DECEMBER 1925. Over 5,000 spectators attend the second-annual Beverly Hills Horse Show. Before the horse show, a parade of horses and bands proceeded down the Sunset Bridle Path. Pictured here is the Santa Monica Band and the bagpipers from the Jinistan Grotto.

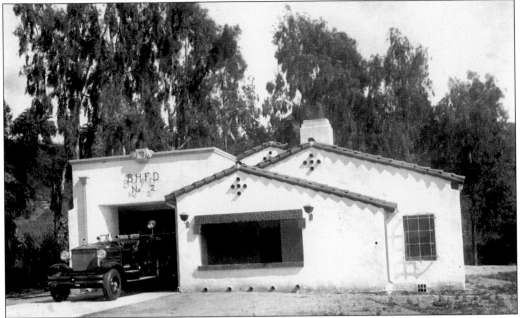

FIRE STATION NO. 2, 1928. The city of Beverly Hills ordered two Ahrens-Fox water-pumping trucks after the new satellite station in Coldwater Canyon was opened. Chief Lloyd Canfield stationed one truck at city hall's fire department headquarters station No. 1 and another at Coldwater Canyon station No. 2.

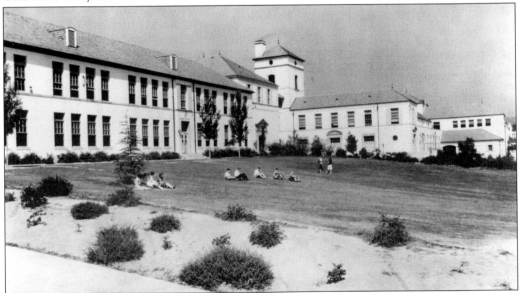

BEVERLY HILLS HIGH SCHOOL, 1935. In 1926, it was announced that Beverly Hills was to build a new high school. By the fall of 1927, the first classes were opened, with 512 students under the administration of the Los Angeles City High School District. The school was built on 19½ acres at a total cost of $500,000, furnished. Years of demand for a local high school resulted in the opening of this French Normandy high school. It was not until 1935 that the local school board took over the jurisdiction of the high school from the Los Angeles School Board, who were operating Beverly Hills Schools until this time.

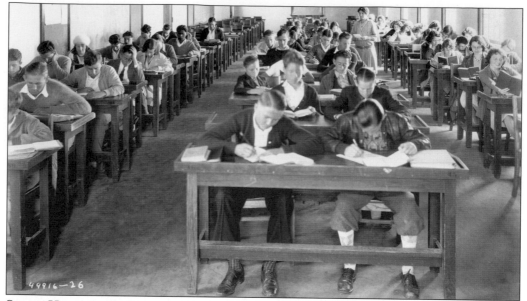

STUDY HALL, 1927. A movement was started in 1930 to bring the high school into Beverly Hills's own school system. On July 1, 1935, the city began its own administration of Beverly Hills High School within the framework of the Beverly Hills School System. The local board of education took over jurisdiction the following year and created its first unified school district.

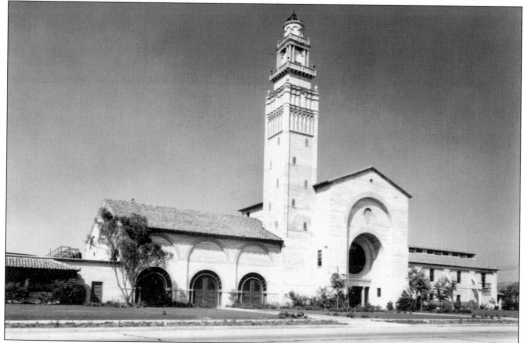

FILTRATION AND WATER-SOFTENING PLANT, 1930. Since the early days of the city's history, water came from springs in Coldwater Canyon. By 1923, with the growth of the population, a water problem had to be solved with the digging of new wells. In 1928, the Sherman Water System (later West Hollywood) was purchased. A new water filtration and softening plant was built in 1927 at 333 South La Cienega Boulevard.

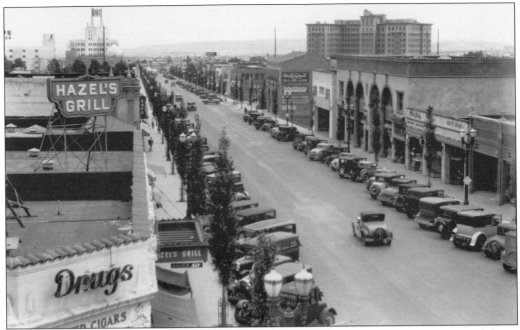

BEVERLY DRIVE, LOOKING SOUTH TO WILSHIRE BOULEVARD, 1928. Beverly Drive did not become a business street until the late 1920s. The businesses were diverse and, over the years, became famous around the world until the 1960s, when Rodeo Drive took over the distinction of being symbolic with that of Beverly Hills. Some of the businesses on Beverly Drive at the end of the 1920s included Hazel's Grill, Beverly Theater, Griffes Sporting Goods, Horton and Converse Pharmacy, Boy's Shop, Piggly Wiggly Market, Beverly Mode Shop, and Beverly Hills Flowers.

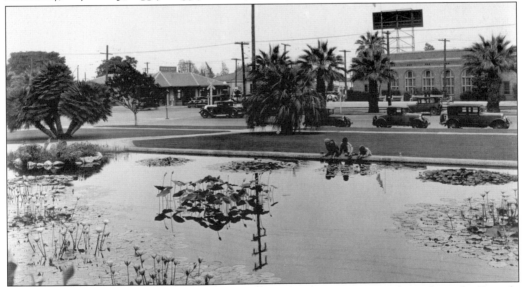

SANTA MONICA BOULEVARD AND BEVERLY DRIVE, 1929. Looking southeast from the Beverly Hills lily pond at the corner of Canon and Santa Monica Boulevard, the Beverly Hills rail station at 470 North Canon Drive was a major landmark. Built in 1896, the station was demolished in 1933 to make way for the new Beverly Hills Post Office building. A new station was built just across Canon Drive on the southwest corner in 1934.

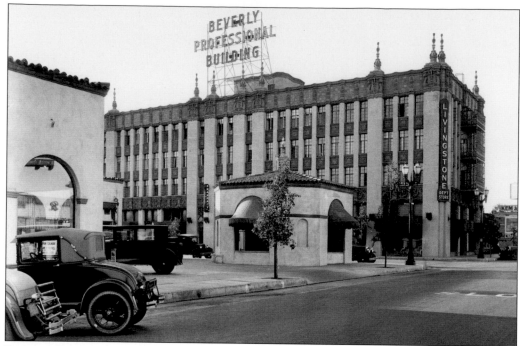

BEVERLY PROFESSIONAL BUILDING, 1929. Located at 9601 Brighton Way at Camden Drive, the Beverly Professional Building exemplified Spanish Colonial Revival style, with Churrigueresque details. It was designed by Harry Werner for real estate entrepreneurs Guy K. Harrison and George Cordingly, representing an investment of $250,000. The five-story building contained 60 office suites and had a neon roof sign that was the largest in the state, measuring 35 feet high and 17 feet long.

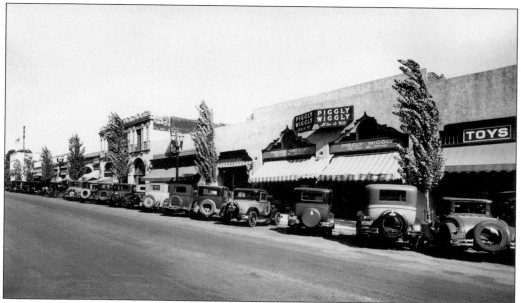

BEVERLY DRIVE NORTH TO BURTON WAY, 1929. Pictured is the business district of Beverly Drive, looking north to what is now South Santa Monica Boulevard. Some of the stores on the eastside of the street include Ralph's Cafe, Piggly Wiggly Market, and Beverly Toys.

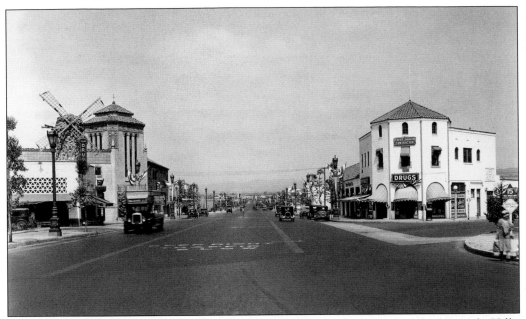

WILSHIRE BOULEVARD AND SAN VICENTE, 1929. This is the eastern end of Beverly Hills, looking west to La Cienega from San Vicente Boulevard. Considered the east gate to Beverly Hills, Wilshire Boulevard was lined with many diverse businesses, such as Miniature Golf, Beverly Hills Pharmacy, Pans Market, Palm Drugs, Van de Kamp's Bakery, Byrd Drug Company, Fred R. Johnson (contractor), and L. C. Bacon, M.D.

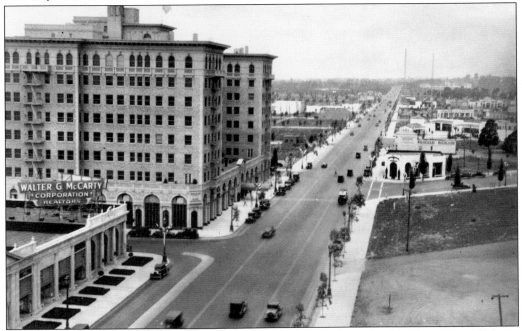

WILSHIRE BOULEVARD, EL CAMINO, AND RODEO DRIVE, 1929. Looking west from Beverly Drive, the newly built Beverly Wilshire Hotel marked the culmination of business development at the end of the 1920s. It was the second major hotel to be built in Beverly Hills after the Beverly Hills Hotel opened in 1912.

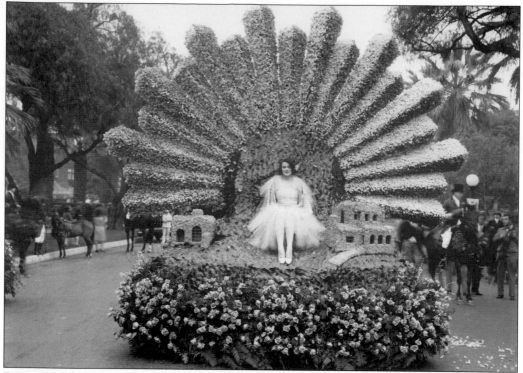

PASADENA TOURNAMENT OF ROSES, 1929. Beginning January 1, 1927, Beverly Hills entered a float in the Tournament of Roses Pageant. Every year, Beverly Hills won top honors—first prize and sweepstakes. The flower girls won first in their class as well. Here Dorothy Bell Dugan represents Beverly Hills for the 1929 Tournament of Roses Pageant. The float won top honors that year.

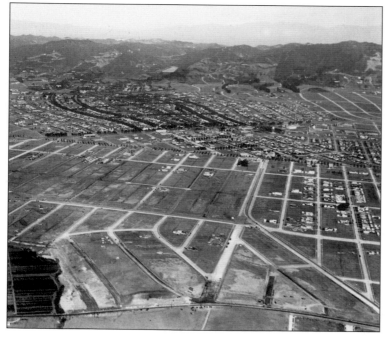

BEVERLY HILLS NORTH OF PICO AND SOUTH BEVERLY DRIVE, 1929. In 1923, the 193 acres known as the Beverly Hills Speedway tract owned by Silsby Spalding, Cliff Durant, and Jake Dansinger was sold to Walter G. McCarty at about $10,000 per acre. By 1924, the entire Speedway property bounded by Wilshire Boulevard, South Beverly Drive, Olympic Boulevard, and Lasky Drive was developed into a proposed residential and business district.

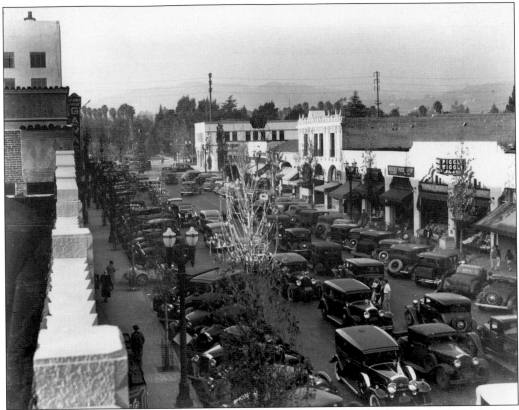

BEVERLY DRIVE NORTH TO SANTA MONICA BOULEVARD, 1928. Traffic jams in Beverly Hills were common throughout the boom of the 1920s, resulting in new traffic laws and intersection lights to ease traffic and auto accidents. Some of the stores shown on the eastside of the street include Piggly Wiggly Market and the Beverly Mode Shop.

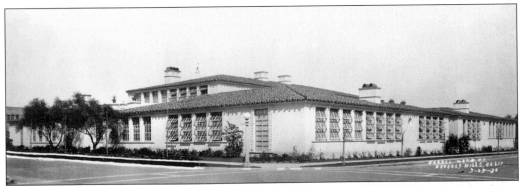

HORACE MANN SCHOOL, 1930. In December 1929, Horace Mann Elementary School was completed at a cost of $232,000. Located at 8701 Charleville Drive, the building is of the Spanish-Mediterranean design typical of all the schools in Beverly Hills. At this time, Beverly Hills had four elementary schools: Hawthorne, Beverly Vista, El Rodeo, and Horace Mann.

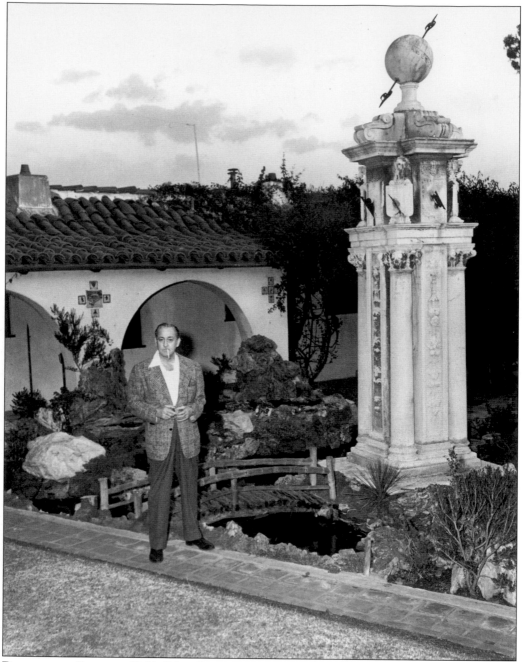

BARRYMORE ESTATE, 1941. John Barrymore is pictured in his garden giving a tour of his estate for *Screen Life* magazine. The estate was originally built by King Vidor and was sold to Barrymore in 1927. Located high on a hill on Tower Road, the 7½ acres overlooks Benedict Canyon. Named Bella Vista after its spectacular views of the city below, the estate was the scene of lavish parties throughout the 1930s. The 7,000-square-foot, Spanish-Mediterranean house and gardens were augmented with the construction of two guest houses, a pool, and a stone cabana. In May 1942, John Barrymore died, leaving Bella Vista as one of Beverly Hills's most talked about legendary estates.

Eight

HOME OF THE STARS
1912–1940

In 1912, Harry and Virginia Robinson, of J. W. Robinsons department stores, were the first to build a mansion north of Sunset Boulevard, behind the Beverly Hills Hotel. Between 1912 and 1916, other important celebrities built homes in the hills or along Sunset Boulevard. King Gillette, the razor king, constructed his home on Crescent Drive at Sunset Boulevard across from the Beverly Hills Hotel. By 1921, Gloria Swanson purchased Gillette's estate, which was later used as a model for the setting for the 1950 film *Sunset Boulevard*. With the influx of famous celebrity bankers and real estate and oil tycoons coming to Beverly Hills, the first of the movie stars began to take an interest in the new city. Silent film stars such as Charles Ray and Corinne Griffith came to Beverly Hills around 1920. The first of the superstars to move to the city, however, were Douglas Fairbanks and Mary Pickford. After Fairbanks and Pickford wed in March 1920, they moved into a remodeled, former hunting lodge they named Pickfair. Doug and Mary took an interest in their new community and helped to promote civic responsibility by encouraging voting in the city and involvement with the chamber of commerce, scouting, the bridle path commission, the flower and horse shows, championing Beverly Hills independence, and the hosting of innumerable charitable affairs. Due to the popularity of Pickford and Fairbanks, other stars soon purchased home sites. Some of the more prominent stars of the 1920s included Will Rogers, Fred Thompson and writer Frances Marion, Harold Lloyd, Rudolph Valentino, Theda Bara, Clara Bow, Tom Mix, Hobart Bosworth, studio moguls Al and Charles Christie, Gloria Swanson, Pola Negri, Wallace Beery, Buster Keaton, Marion Davies, writers Fannie Hurst and Dorothy Parker, MGM mogul Louis B. Mayer, Universal mogul Carl Laemmle, studio mogul Thomas H. Ince, and Charles Chaplin, among many others.

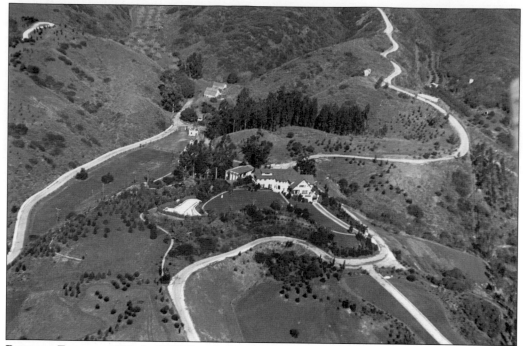

PICKFAIR ESTATE, 1920. In 1919, Douglas Fairbanks acquired about 18 acres of land surrounding a hunting lodge in the hills of Benedict Canyon from Los Angeles attorney Lee A. Phillips. Located at 1143 Summit Drive, the house was remodeled into a mansion around 1925. Douglas Fairbanks married Mary Pickford in 1920, only a year after Doug had moved into his house. A crescent-shaped swimming pool was built at the foot of the rear lawn, and in the canyon below the house, Doug built a six-stall stable for his horses.

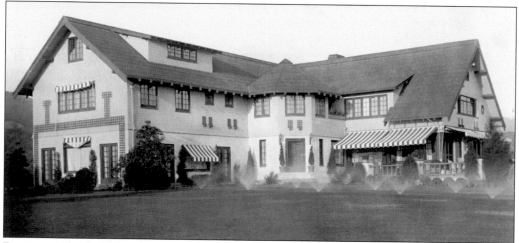

PICKFAIR, 1920. The remodeling of the main house by architect Wallace Neff resulted in a mock-Tudor design, situated on a hill with a view of Beverly Hills below. There were two wings, one 95 feet long and the other 125 feet, facing the front lawn with a view of the canyon below. The first floor consisted of a large entrance hall, screening room, living room, and dining room, which led to a glassed-in sun porch, breakfast room, kitchen and servants' quarters. Doug's bedroom suite and five guest bedrooms occupied the second floor, and a bowling alley and billiard room were on the third floor.

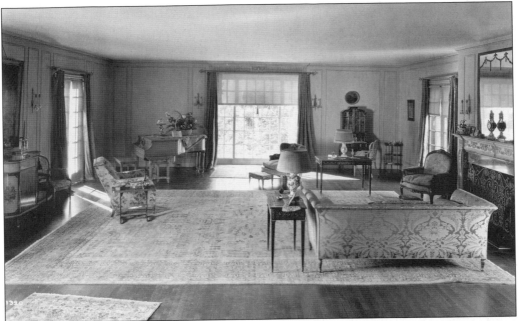

PICKFAIR, 1920. The Pickfair living room boasted minimalist interior design with antique reproduction furniture. Mary Pickford once noted that the house was "luxurious, dignified and comfortable and retained its status in spite of the many passing fads." This was the room where Doug and Mary would entertain friends and visitors alike for over 30 years. The exterior and interior were remodeled again in 1934 by architect Wallace Neff.

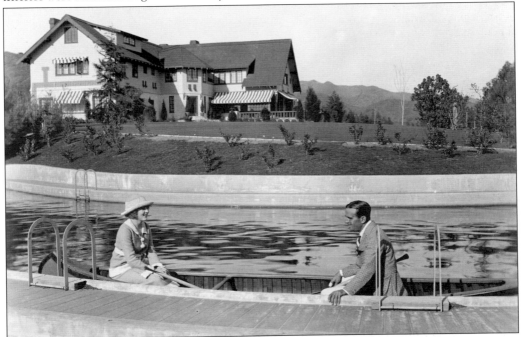

PICKFAIR, 1922. Here Douglas Fairbanks and Mary Pickford canoe in the Pickfair swimming pool. The pool was one of the most popular places on the estate. Pickfair became one of the most famous estates in the world and was photographed for over 30 years by the international press.

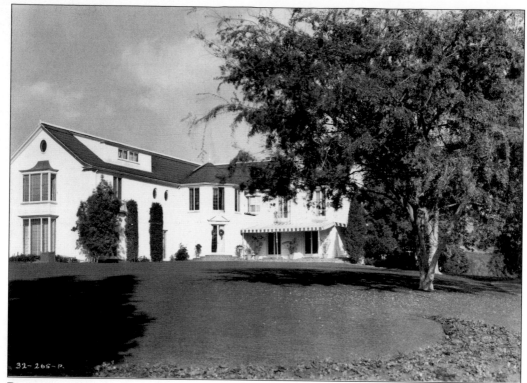

PICKFAIR, 1935. Architect Wallace Neff was brought back again to remodel the mansion into an English Regency house. He dispensed with the ugly dormers in the west wing and cut back the overhanging gables. He replaced out-of-scale attic vents with oval lunettes and installed Regency bay windows with wrought-iron Regency verandas.

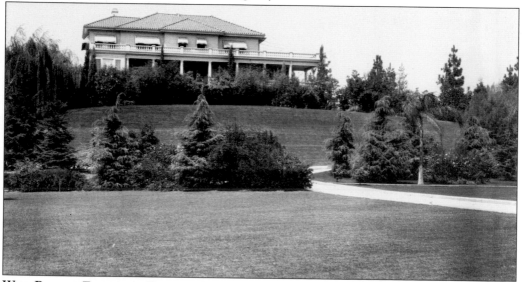

WILL ROGERS ESTATE ON BEVERLY DRIVE, 1921. Humorist Will Rogers acquired a mansion at 925 North Beverly Drive, including a full-sized polo field and stables. The back end of the house fronted on Crescent Drive. After playing polo on his field, Rogers would walk over to the Beverly Hills Hotel across the street for a drink at the bar, which was later named the Polo Lounge.

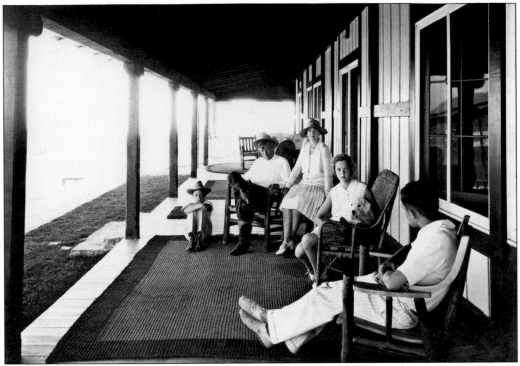

WILL ROGERS AND FAMILY, 1921. Will Rogers is pictured here with his family, on the porch of the stable house near Lexington Drive on the north end of his property. From left to right are Jimmy, Betty, Mary, and Will Jr. The estate included, along with the polo field, stables, a riding ring, two log cabins, and a swimming pool. By the 1930s, Rogers moved to his Pacific Palisades ranch. He eventually sold his Beverly Hills property, which was later subdivided.

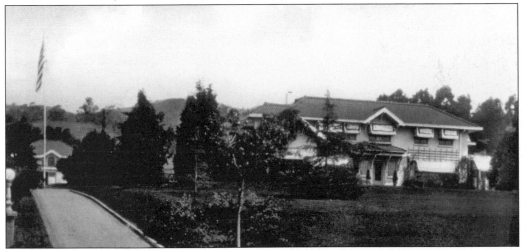

PAULINE FREDERICK HOME, 1918. Motion picture star Frederick built her home at 503 Sunset Boulevard just west of Hillcrest Drive, the first movie star to live in Beverly Hills. The estate included her own stables for her prized horses and a guest house in the rear. She lived in her Beverly Hills estate with her second of five husbands, actor-playwright-screenwriter Willard Mack. A Broadway actress who started in films from 1915 on, she became one of Hollywood's biggest stars. She could be seen riding her horses on the Beverly Hills Bridle Path for many years.

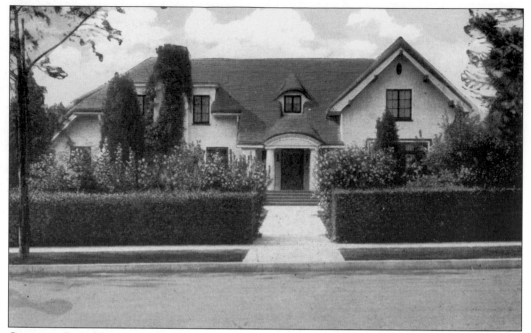

CHARLES RAY HOME, 1921. Charles Ray was one of the earliest film stars to move to Beverly Hills. His English cottage–style house at 901 North Camden Drive became a landmark on the northwest corner of Camden and Sunset and was a tourist attraction throughout the 1920s. Ray's stardom was made on his portrayal of "country boy" parts for Thomas Ince. In 1922, he started his own Hollywood studio and put up his own money to make the epic film *The Courtship of Miles Standish* in 1923, but he went bankrupt after the film bombed, and he lost his studio and home.

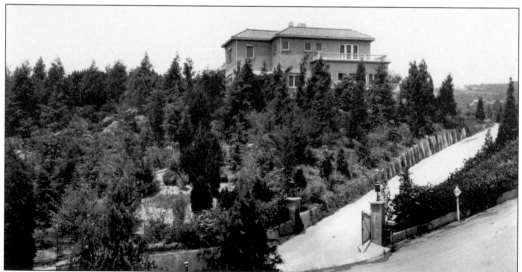

CHARLES CHAPLIN ESTATE, 1923. One of the first stars to leave his Hollywood home for Beverly Hills was Charles Chaplin. In 1922, he broke ground for a large Spanish-style home at 1085 Summit Drive, just down the road from Pickfair. The new estate would be a bachelor home, since Chaplin was divorced by the time the house was completed. It was called the "break-a-way house," because studio craftsmen did the exterior and interior design work.

CHAPLIN AND PAULETTE GODDARD, 1932. The two-story, four-bedroom, Spanish-style mansion, with its several acres of gardens surrounding the estate, was Chaplin's principal home until he left for Europe in 1952, never to return. He married actress Lita Grey in November 1924, and she moved into the house until they divorced in 1927. Six years later, he secretly married actress Paulette Goddard. Their marriage was not publicly known until 1936. Paulette lived at the Chaplin estate until their subsequent divorce in 1942.

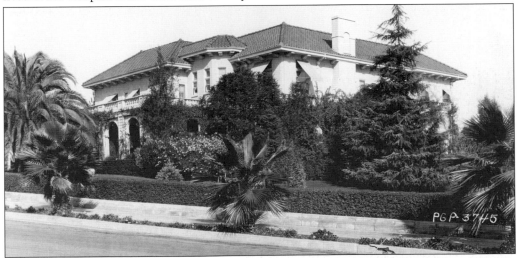

GLORIA SWANSON ESTATE. In 1922, Gloria Swanson purchased razor-blade millionaire King C. Gillette's three-year-old mansion at 904 North Crescent Drive, across the street from the Beverly Hills Hotel. The Italian Renaissance–style mansion was one of the largest to be built north of Sunset Boulevard. Swanson had been living at the Beverly Hills Hotel until she purchased the Gillette estate. The Swanson house was one of the film star–style homes that inspired the art direction for the 1950 film *Sunset Boulevard*.

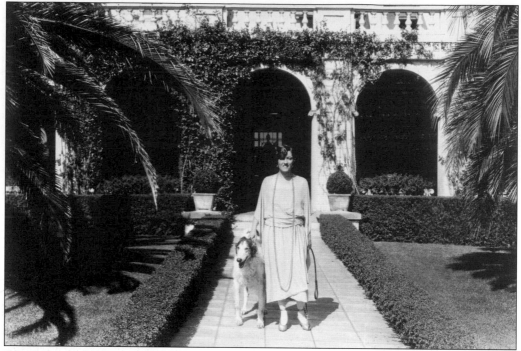

SWANSON AT CRESCENT DRIVE ESTATE, 1922. The King Gillette house was one of the great showplaces in Beverly Hills at the time, with 22 rooms, five baths, and one automatic electric elevator. When Gloria came out of her new home for the press with her Russian wolfhound Ivan, she was instantly placed among Beverly Hills royalty.

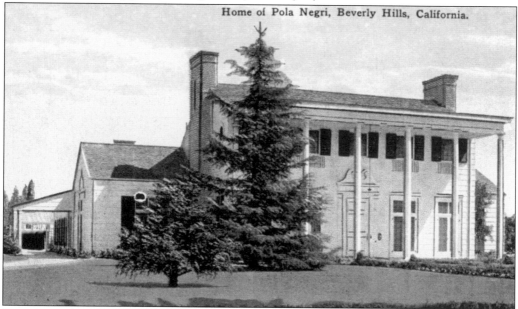

Home of Pola Negri, Beverly Hills, California.

POLA NEGRI'S HOME, 1923. Due to her friend Charles Chaplin moving to Beverly Hills, actress Pola Negri followed and purchased a Mount Vernon–style home at 610 North Beverly Drive. Pola added a Roman plunge–styled swimming pool in her backyard, beginning the tradition of exotic amenities in movie star homes of Beverly Hills.

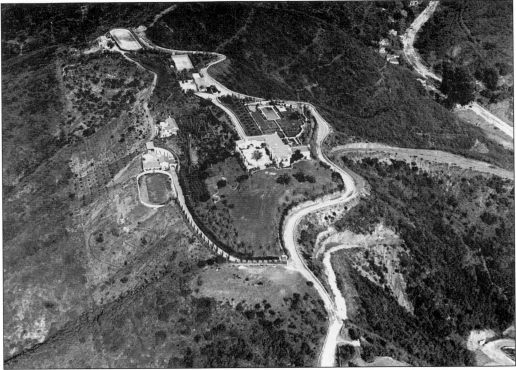

FRANCES MARION ESTATE, ENCHANTED HILL, 1924. In 1923, scriptwriter Frances Marion and actor-husband Fred Thompson purchased a hilltop above Benedict Canyon and built one of Beverly Hills's most lavish estates, on 16 acres at 1441 Angelo Drive. Architect Wallace Neff designed a beautiful, 28-room California Spanish–style mansion surrounded with landscaped grounds that included stables, riding paddock, guest houses, a swimming pool, gardens, and tennis courts.

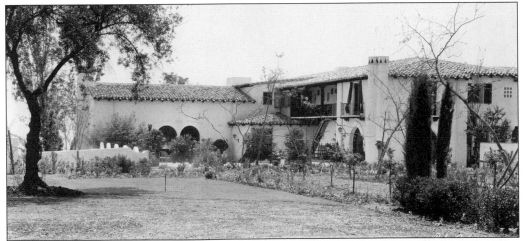

ENCHANTED HILL, 1924. This rear view of the house shows the arched windows of the living room at left and the second floor bedrooms over the arched window of the dining room. Architect Wallace Neff and the owners resolved to make the place exotic, unusual, and even theatrical. Enchanted Hill became one of the most lavish of the estates of Beverly Hills, with commanding views of the entire city below, from downtown Los Angeles to the Pacific Ocean.

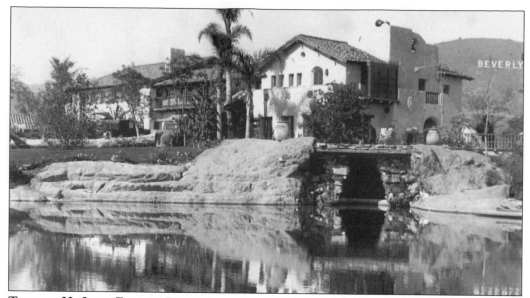

THOMAS H. INCE ESTATE, DIAS DORADOS, 1924. The famed motion picture director and studio mogul built his California Spanish Mission–style estate in Benedict Canyon between 1923 and 1924. Constructed on 30 acres at 1051 Benedict Canyon Drive, the entire estate was designed by architect Roy Selden Price as a motion picture setting. Ince and Price turned the new estate into a theatrical version of an old Mission-style mansion, with such exotic amenities as a living room with a stone fireplace and a circular motif with a totem pole in the center of the room. The basement screening room was made into a romantic version of a pirate ship's deck, the swimming pool into a rock pond and a circular billiard room.

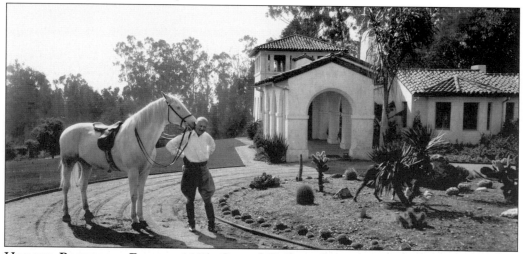

HOBART BOSWORTH ESTATE, 1925. One of Hollywood's earliest film actors was Hobart Bosworth, who started his career as a stage actor and entered the motion picture business in 1909. Bosworth was the first to produce Jack London stories into motion pictures and was one of the founders of Paramount Pictures in 1914. In 1924, he and his wife moved to Beverly Hills and purchased a four-acre property on Hillcrest Road, just north of Sunset. They built a Spanish-style hacienda at 809 Hillcrest Road that included a stable for his horse. He was a contributor to the construction of the Beverly Hills Bridle Path and rode his horse Cameo on it, which helped make it a tourist attraction.

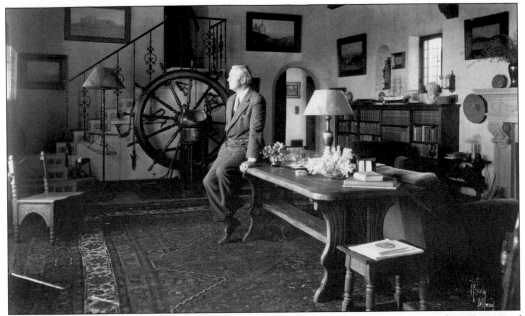

BOSWORTH IN STUDY, 1927. Famed actor Hobart Bosworth was known as the "Dean" of Hollywood, having been one of the first motion picture actors. Bosworth was an accomplished artist and devoted a room in the house as a studio. He represented Beverly Hills at the annual horse shows and was Beverly Hills's best known celebrity. He and his wife suffered severe losses after the 1929 Wall Street crash and were forced to sell the beloved estate in 1933. The new owner was actor William Powell, who transformed the Spanish-style mansion into a magnificent Georgian-style residence.

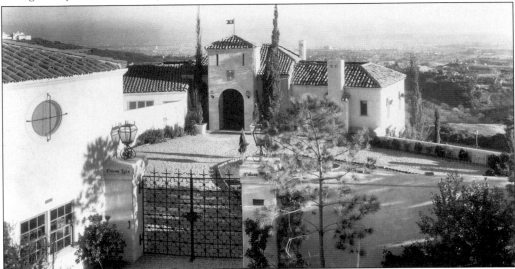

VALENTINO'S FALCON LAIR, 1926. Beverly Hills developer George Read sold a beautiful Spanish-style Benedict Canyon estate at 1436 Bella Drive to famed motion picture star Rudolph Valentino in 1925. The estate, named Falcon Lair due to it being built on a cliff overlooking the canyon below, became one of the most exotic Beverly Hills tourist attractions after Valentino's death in 1926. The estate was not a very large house, but its eight-acre hillside property included Italian gardens and a stable area below.

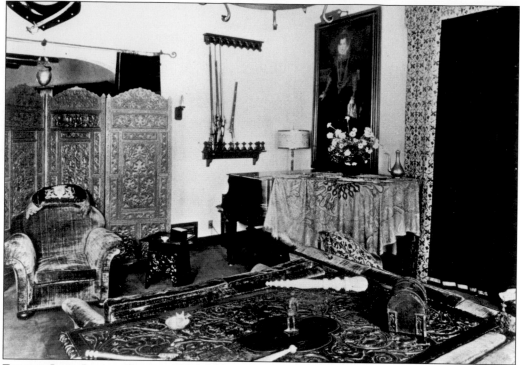

FALCON LAIR LIVING ROOM, 1926. Valentino's house had 16th-century, solid oak Florentine front doors, and the rooms were decorated in the old world European style. The hall floor was travertine, the walls were painted taupe, and the floors were covered in seamless taupe Axminster wool carpeting. The living room, pictured here, featured his draped piano, carved screen, and a 17th-century portrait of a woman. The rooms were filled with antiques Valentino had acquired during buying trips in New York and European auction houses.

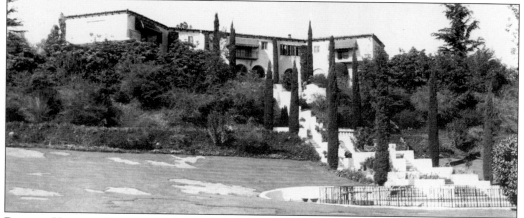

BUSTER KEATON ESTATE, 1927. In 1926, Buster Keaton and his wife, Natalie, moved into a newly constructed $300,000 estate at 1004 Hartford Way in Beverly Hills. The Italian Villa style mansion at the mouth of Benedict Canyon became a showplace in Beverly Hills fit for a Hollywood star. The 20-room, three-acre estate with guest house and swimming pool is one of Beverly Hills most celebrated properties to this day. By 1933, Natalie sold the estate (at the time of her divorce). After a succession of celebrity owners over the years, James and Pamela Mason acquired it in the 1950s.

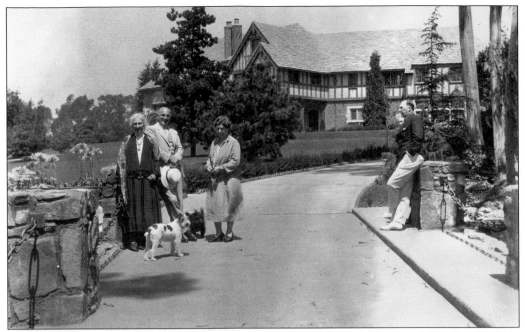

CHRISTIE ESTATE, 1926. Well-known motion picture studio moguls Al and Charles Christie built their Tudor-style family estate, Waverly Mansion, at 501 Sunset Boulevard and Hillcrest Road in 1926. Pictured here, from left to right, are their mother, Mary, Al Christie, sister Anne, and Mr. and Mrs. Charles Christie. Al Christie came with the Nestor Film Company to Hollywood in 1911 and built the first film studio in Hollywood. Al and his brother produced silent comedies and feature films for Universal and later owned studios and were involved in real estate, including the development of Studio City.

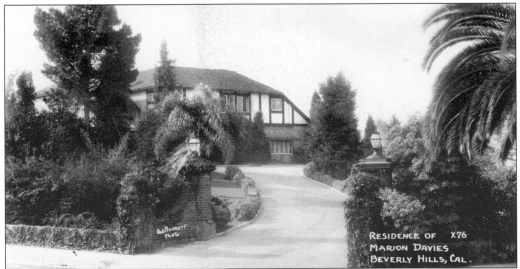

RESIDENCE OF MARION DAVIES, 1925. One of the more famous Beverly Hills residences was film star Marion Davies' mansion at 1700 Lexington Road. She called her home "Beverly House" and entertained Hollywood and celebrity guests there for many years. Her dining room could seat 100 people comfortably, and she entertained regularly when in Beverly Hills. By 1946, she purchased an estate nearby for herself and William Randolph Hearst, where he died in 1951.

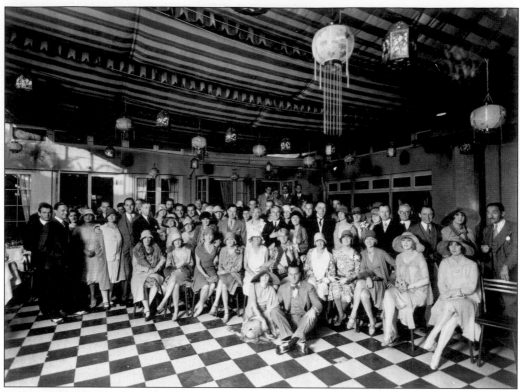

MARION DAVIES PARTY, 1927. Actress Marion Davies, Hearst's mistress, hosted parties at her home at 1700 Lexington Road for many years, bringing a little bit of "Hollywood" to Beverly Hills. Pictured here at one of her parties are Hollywood celebrities Mary Pickford, Buddy Rogers, Charles Chaplin, Gloria Swanson, director D. W. Griffith, Adolph Menjou, Anita Stewart, and Louise Brooks, among other notables.

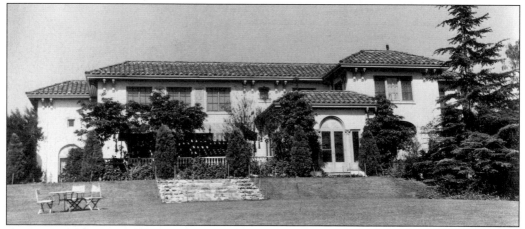

TOM MIX ESTATE, 1924. Just down the hill from Charles Chaplin's estate was the famed Western star Tom Mix's estate at 1010 Summit Drive. Mix and his wife moved from their Hollywood home to Beverly Hills in 1923 and lived in a 19-room Italian villa–styled mansion. The five-acre property was protected by a massive wall along the road and surrounded by formal gardens. The property had its own stables like many others in the area, and Mix could be seen riding on the bridle path in Benedict Canyon and along Sunset Boulevard.

MIX'S LIVING ROOM, 1925.
Western star Tom Mix is seated on
one of his silver saddles in his living
room at the Summit Drive house.
One of the parlors belonged to Mix's
collection of western memorabilia.
The room had a 20-foot-high
beamed ceiling, where his small
arsenal of rifles and guns were on
display and where his collection of
American Indian artifacts, medals,
and trophies could be seen. Mix
and his wife, Victoria, entertained
often, with many of their celebrity
neighbors
in attendance.

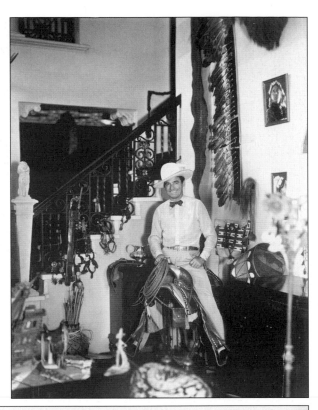

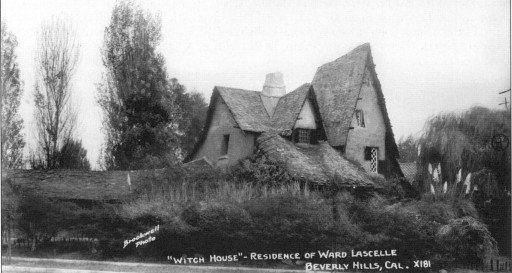

RESIDENCE OF WARD LASCELLE, 1928. Originally built in 1921 as the administration building
for Irvin Willat Productions in Culver City, the building was designed by Harry Oliver (designer
of the Van De Kamp bakery Windmills) and moved to Carmelita and Walden Drive in Beverly
Hills as a residence in 1926. The inspiration for the design of the house was taken from old
postcards of English cottages with thatched roofs that Harry Oliver found on one of his trips to
England. Ward Lascelle was a motion picture producer who lived in the house for a number of
years until it was sold to another family.

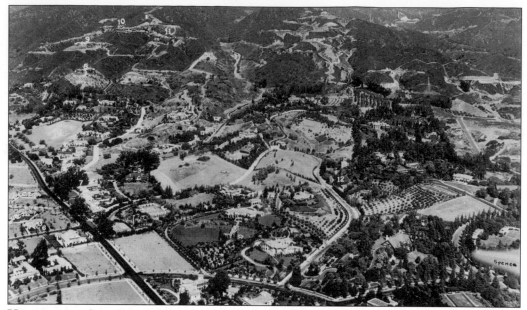

HOME OF THE STARS, 1930. Beginning around 1919, when movie stars began to live in Beverly Hills, some built their homes on lots purchased from local real estate companies and others purchased already existing estates built during the first decade of the area's development. This photograph shows the movie star homes identified with numbers and names below. Throughout the 1930s, stars could be seen on the streets of Beverly Hills. George Burns, Lloyd Nolan, Ann Sothern, Joan Bennett, Joel McCrea, Janet Gaynor, Frederic March, Linda Darnell, and John Payne all could be seen in films that were shot in and around Beverly Hills.

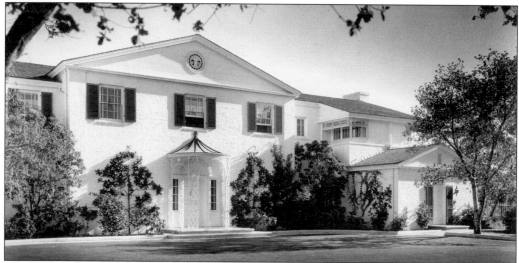

DAVID O. SELZNICK ESTATE, 1936. Film producer David O. Selznick's new home at 1050 Summit Drive was designed in Georgian Colonial style by architect Roland E. Coate in 1934. Selznick shared the home with his wife, Irene Mayer Selznick, for many years until their separation in 1945 and divorce in 1948. The estate was featured in *Architectural Digest* shortly after the Selznicks moved in. Irene Selznick once said that "Our life together was dominated by parties, gambling, and most of all—work." The interior design was neoclassical in style, with elements of Regency furniture and decoration.

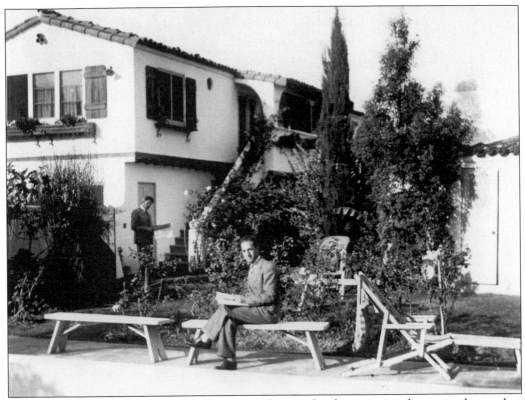

George Gershwin Home, 1936. Composer George Gershwin is seated next to the pool at 1019 Roxbury Drive. The house was originally built in 1928 and was leased by George and Ira Gershwin shortly after their arrival in California in late 1935. It had 21 rooms, 8 bathrooms, and 6 bedrooms and measured 6,393 square feet. While in California, George wrote "Shall We Dance" for Fred Astaire and Ginger Rogers, among others. His health took a downturn in early 1937, and by July, he had died of a brain tumor, shortly before his 39th birthday.

George Burns and Gracie Allen Home, 1937. The Burns and Allen home at 720 North Maple Drive was designed in the American Colonial style with six bedrooms, two of them suites with sitting rooms and dressing quarters, an open dining area, servants' quarters, and a medium sized swimming pool. At the time this photograph was taken, the comedy team of Burns and Allen were making films at Paramount and at the same time appearing on the radio nationwide.

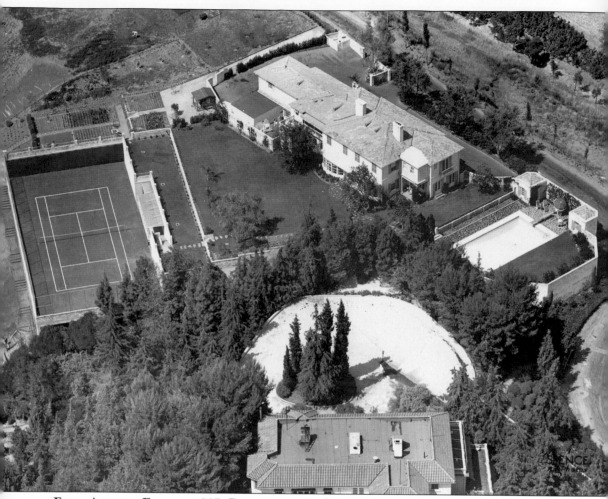

FRED ASTAIRE ESTATE, 1937. Dancer-actor Fred Astaire's estate at 1121 Summit Drive was located next to Charles Chaplin's circular driveway. Astaire is known for being the king of the movie musicals of the 1930s. He built this house in the growing colony of motion picture stars that moved to Beverly Hills in the early 1930s. Astaire lived at the Summit Drive house for many years until he built a house on San Ysidro Drive for himself and his daughter in 1960.

Nine

THE MOTION PICTURE INDUSTRY
1915–1940

With the popularity of Beverly Hills among the motion picture personalities that were residents since 1919, motion picture companies themselves began to use the city as a backdrop for films that needed the lush landscape and grand mansions that Pasadena also offered. As early as 1918, Douglas Fairbanks starred in *He Comes Up Smiling*, made by Paramount at the Silsby Spalding estate, Greyhall, a former hunting lodge built in 1909. He would later live there before building his own house nearby. After the Beverly Hills Hotel was opened, there was a small cinema theater in the hotel for guests and residents. Not until 1925 did the Beverly Theater open, becoming the first "movie palace" in the town. The early days of the city were more like a country club than a real estate development. On many occasions, Will Rogers, who lived across the street from the Beverly Hills Hotel, could be seen at the bar with his friends after a game of polo. Residents had private dinners and birthday parties for their children while business deals were made in and around the hotel. It was not until the 1920s that the boom in movie celebrities moving to Beverly Hills began.

The most important celebrities to move to Beverly Hills were Douglas Fairbanks and Mary Pickford. They helped place an international spotlight on the city when they purchased a former hunting lodge in the hills above the Beverly Hills Hotel and began to remodel it into a home in 1920. Their estate, Pickfair, became known as the "Western White House" and was visited by domestic and foreign dignitaries for over 20 years. It was the most famous Beverly Hills landmark and was a magnet for visitors from around the world. Following Mary and Doug, other film stars such as Chaplin eventually moved to Beverly Hills. In 1921, Chaplin used Sunset Park (across from the Beverly Hills Hotel) for scenes in *The Idle Class*, in which he plays a bum sleeping in a park and being awakened by a police officer. It was at this time that the Beverly Speedway became a major sports attraction, bringing countless thousands of people to the city. When the Speedway opened, a film company made a racing picture on the track entitled *The Roaring Road*. In 1923, the Beverly Hills Hotel was featured in Harold Lloyd's *A Sailor-Made Man*, in which a young man (Lloyd) tries to see his girlfriend while she is with her parents at a resort hotel.

CHAPLIN AT SUNSET PARK, 1921. Charlie Chaplin, who had recently moved to Beverly Hills, began using the town as a background for some of his films. His studio was located at La Brea and Sunset Boulevard in Hollywood, but he utilized locations around the Los Angeles area frequently. For the film *The Idle Class*, Beverly Hills acted as a rich and prosperous locale and was a perfect setting for his tramp character to be harassed by the Beverly Hills police while he tried to get some sleep in the park.

BEVERLY HILLS SPEEDWAY, 1921. The Beverly Hills Speedway was the perfect location for a race car film entitled *The Roaring Road*. The Speedway was used for many public events such as horse shows, flower shows, and for filmmakers who needed a racetrack background. The area at this time was composed of wide-open fields, making it again a perfect location for aviation pictures as well.

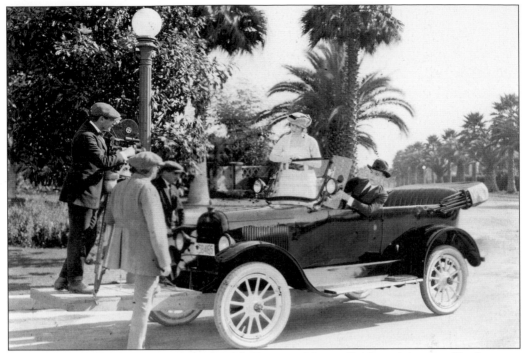

THOMAS INCE PRODUCTIONS, 1921. Beverly Drive and Sunset Boulevard acts as a film location for an Ince production starring Douglas MacLean (driving the car). The Thomas Ince Studio was located in nearby Culver City, making it convenient for film companies to come over to Beverly Hills for its lush landscaping and large mansions. Note the camera platform attached to the front of the car for motion shots while driving the streets of Beverly Hills. Beverly Hills acted as a backdrop for many films as early as 1913 and helped publicize the city all over the world.

LEWIS ESTATE POOL AREA ON ANGELO DRIVE, 1926. Industrialist George Lewis built a magnificent estate on 10 acres at the end of Angelo Drive in 1925. By 1926, Paramount Studios chose the Lewis estate as a location for the film *Kid Boots*, starring Eddie Cantor and Clara Bow. The film in part takes place in a town of millionaires and involved inheritance, estates, and golf tournaments.

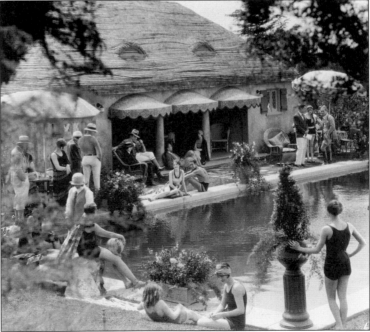

IRVING HELLMAN ESTATE AT HARTFORD AND OXFORD, 1927. The entrance gates of the Hellman Estate and intersection of Hartford and Oxford were used for the MGM film *Heaven on Earth*, which starred Renee Adoree and Beverly Hills resident Conrad Nagel. The Hellman estate was originally built by Roland P. Bishop and later sold to banker Hellman. The area north of the Beverly Hills Hotel was dotted with fine European-style mansions and grounds that doubled as a background for Europe. For the film *Heaven on Earth*, the gates and streets resembled France during World War I.

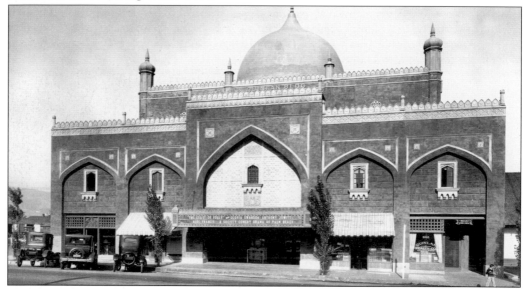

BEVERLY THEATRE AT WILSHIRE BOULEVARD AND BEVERLY DRIVE, 1929. In 1925, Beverly Hills's first "movie palace" was built by Beverly Hills real estate pioneer Dan M. Quinlan. Located on the northeast corner of Beverly and Wilshire Boulevard, the theatre was designed by architect L. A. Smith in East Indian decor with a distinctive onion dome. The caption of this photograph reads, "The stars own theatre, the Beverly, adjacent to Wilshire Boulevard on Beverly Drive. The dome of this theatre has long been the chief designation to motorists of the city of Beverly Hills." The theatre opened on May 18, 1925, with the premiere of *I Want My Man*, starring Milton Sills and Doris Kenyon, and was demolished in September of 2005.

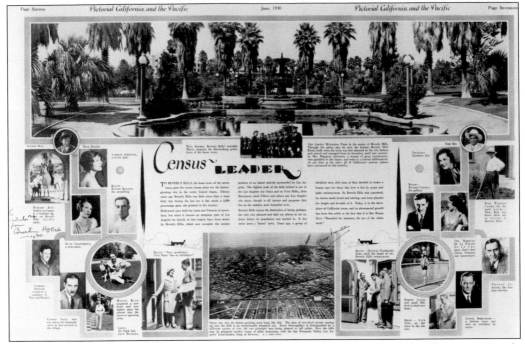

BEVERLY HILLS PICTORIAL, 1930. A special supplement in the *Los Angeles Times* on Beverly Hills names the community as the "Census Leader." Excerpts from the pictorial said, "To Beverly Hills, the home town of the movie stars, goes the recent census plum for the fastest-growing city in the entire United States." Some of the movie star residents are pictured as follows: Will Rogers, Buster Keaton, Charles Chaplin, Conrad Nagel, Tom Mix, Gloria Swanson, Ronald Colman, Harold Lloyd, and Lionel Barrymore.

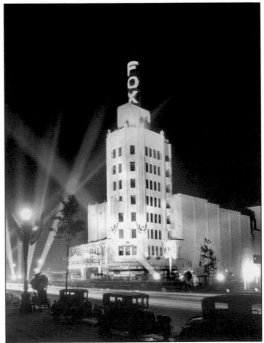

FOX WILSHIRE THEATRE, 1930. One of Beverly Hills's most lavish art deco theatres, the Fox Wilshire is still located on the southeast corner of Hamilton and Wilshire Boulevard. When it was opened on August 3, 1930, it was among the first pure art deco theatres in California, designed by architect S. Charles Lee. The silver-and-black chevrons dominating the design were a popular art deco trademark. The theatre opened with Paramount's *Animal Crackers*, starring the Marx Brothers. Throughout the 1930s, the Fox Wilshire was host to several Hollywood premieres, such as *Young Mr. Lincoln*, starring Henry Fonda in 1939.

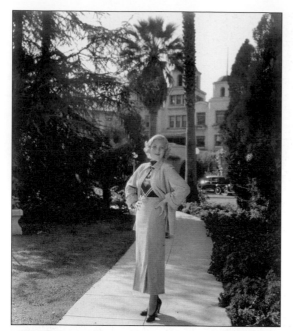

ANN SOTHERN, 1935. The Beverly Hills Hotel is the background for a Columbia Studio publicity fashion shoot with star Ann Sothern. The photograph caption read, "Trim for street in this grey ribbed velvet suit worn by Ann Sothern, Columbia star of *Eight Bells*. Three-piece suit shows straight line skirt and boxed, trotteur coat of grey with jersey under blouse geometrically striped in lipstick red, grey and white." The Beverly Hills Hotel was used for fashion photography, press conferences, meetings, social functions, filmmaking, and many other Hollywood and industry events.

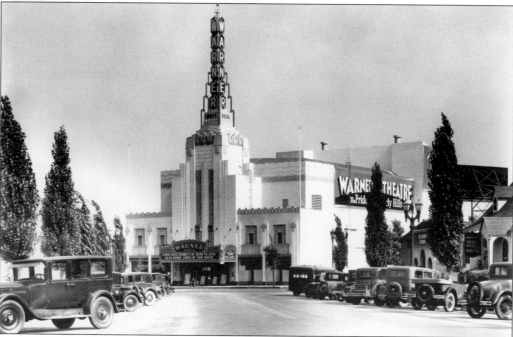

WARNER BEVERLY HILLS THEATRE, 1931. It was reported that "Warner Brothers has again given a modernistic expression to the theatrical spirit in creating the new Warner theatre in Beverly Hills, from a design by B. Marcus Priteca, architect." Warner's theatre on the southwest corner of Wilshire Boulevard and Canon Drive was the site of the premiere for *The Millionaire*, starring George Arliss, on May 19, 1931. The building's architecture was Italian art deco. The lobby was decorated in Genesee Rose marble with silver and other metallic trimmings and multi-paneled mahogany doors with gold leaf decorations. The Warner Brothers theatre division called the Warner Theatre "The Pride of Beverly Hills."

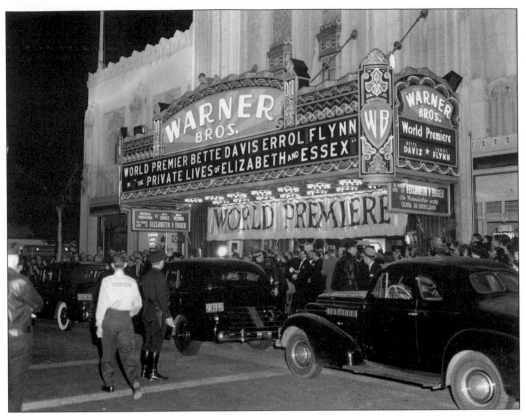

WARNER BROTHERS BEVERLY HILLS THEATRE, 1939. Beverly Hills had three flagship theatres in the city that regularly premiered films, making the town indeed the "city of the stars." Warner Brothers premiered Bette Davis and Errol Flynn's film *The Private Lives of Elizabeth and Essex* on November 11, 1939, at the Warner Theatre.

DOHENY PARK, 1931. The Educational Pictures–Mermaid Comedy short *Once a Hero* is pictured here on location at a Doheny Park fountain. Mermaid stars T. Roy Barnes and Monty Collins (in the fountain) used the park and fountain as a backdrop for a story about a bank cashier who inadvertently captures a robber and becomes a hero. The park originally opened in 1931 as part of a two-mile strip park named Beverly Gardens. It was 22 blocks long from the western border to the eastern border of the city at Doheny Drive along Santa Monica Boulevard. The fountain centered in the park is the work of architect W. Asa Hudson.

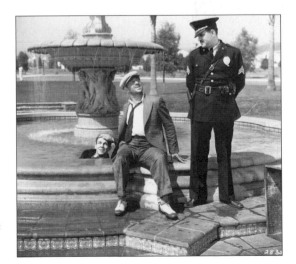

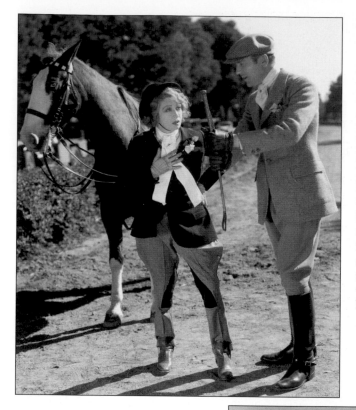

RODEO DRIVE BRIDLE PATH, 1932. Universal Studios used the Beverly Hills Bridle Path on Rodeo Drive as a background for the comedy film *The Cohens and Kellys in Hollywood*, starring June Clyde as Kitty Kelly (seen here). The film has Kitty coming to Hollywood to become an actress and make a lot a money in order to bring her family to Beverly Hills. Once the Kellys arrive, they buy a mansion and live the life of the upper class. The Cohens follow the Kellys to Hollywood as well. After losing all their money on faulty business ventures, the families move back to where they came from.

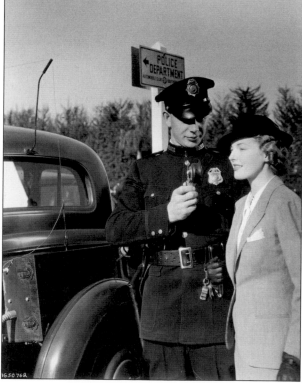

BEVERLY HILLS POLICE AND HOLLYWOOD PUBLICITY, 1933. The caption on this photograph reads, "The very latest in crime detection. The Beverly Hills police have sending as well as receiving sets in their police cars. This enables them to talk with headquarters as well as receive crime calls. Pretty Jean Chatburn, an MGM featured player, is shown the new device by Officer W. E. Gardell."

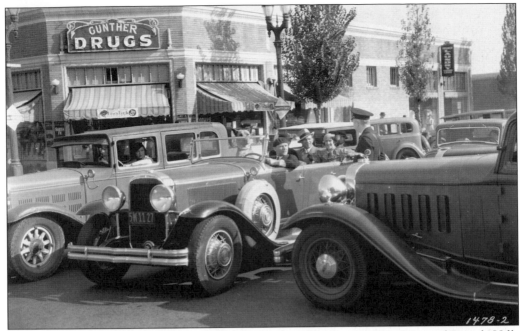

Rodeo Drive and Burton Way, 1934. During the 1930s, Paramount often used Beverly Hills streets, buildings, and residences as film locations. For the comedy *Six of a Kind*, Charles Ruggles drives George Burns and Gracie Allen through the intersection at Rodeo Drive and what is now South Santa Monica Boulevard. This photograph shows the site of the first drugstore (behind the traffic jam) in Beverly Hills, which opened on the southwest corner by Frank Homer in 1920. It was the second store of any kind in Beverly Hills. Later the same store was sold to the Gunther family.

George Lewis Estate, 1932. The George Lewis estate, built in 1925 at the end of Angelo Drive, was used continually throughout the 1920s and 1930s as a film location. Pictured at the front gate of the estate are Laurel and Hardy and Jacquie Lynn (the child) in a scene from *Pack up Your Troubles*. For this Hal Roach comedy, Laurel and Hardy play World War I veterans who take care of a young girl whose father was killed during the war. After looking for family members to return the child to, they accidentally find out that her grandfather is the president of a large bank and is very rich. They return the child to his care.

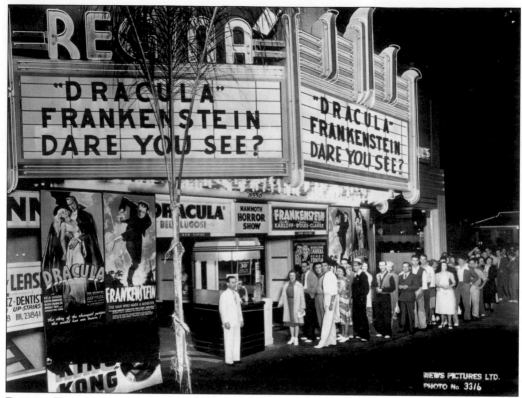

REGINA THEATRE, 1938. Beverly Hills had four theatres in operation by the late 1930s—one a neighborhood house and the other three, flagship theatres each seating more than 2,000 people. The Regina Theater at 8556 Wilshire Boulevard was an extremely popular venue in Beverly Hills for younger theatergoers, especially when they were showing horror films such as the reissue classics *Dracula* and *Frankenstein*. By the 1950s, the theatre was renamed the Fine Arts Theater, playing predominately foreign releases.

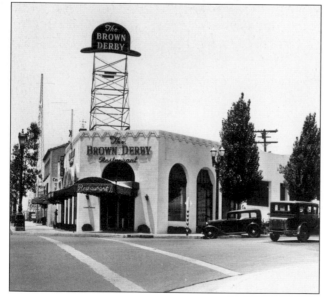

BEVERLY HILLS BROWN DERBY, 1932. Brown Derby owner Robert Cobb opened the Beverly Hills Brown Derby in 1931 on the northwest corner of Rodeo Drive and Wilshire Boulevard. Immediately after opening, the Derby became one of Beverly Hills most enduring landmarks. For years, patrons of the Derby included Charles Chaplin, John Barrymore, Fred Astaire, Gary Cooper, James Stewart, Jack Benny, George Burns, Douglas Fairbanks, Mary Pickford, and Marion Davies, among many others. The Derby closed in 1982 and was subsequently demolished to make way for a store.

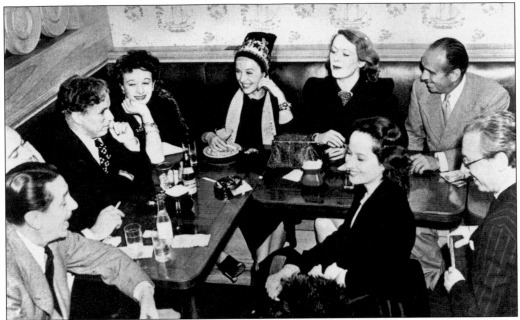

BROWN DERBY, 1939. Charles Chaplin and Douglas Fairbanks party at the Beverly Hills Brown Derby several months before the death of Fairbanks in December 1939. From left to right are actor Reginald Gardner, Mr. Blecke, Charles Chaplin, Mrs. Blecke (Sylvia Ashley's sister), actress Paulette Goddard, Sylvia Ashley Fairbanks, director Alexander Korda, and actress Merle Oberon.

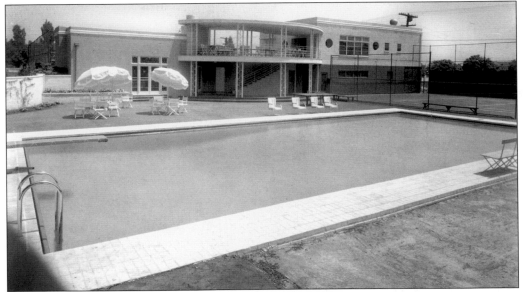

BEVERLY HILLS TENNIS CLUB, 1938. Once located at 340 North Maple Drive, north of the intersection of Third and Maple, the Beverly Hills Tennis Club became a haven for the movie colony. Designed in Streamline Moderne style, the club hosted tennis tournaments and private tennis parties for over 30 years. The main building was designed with a bar and food service area, viewing lounge, dressing rooms, showers, lockers, and offices. The grounds included several professional tennis courts, a full-sized swimming pool, and a garden area.

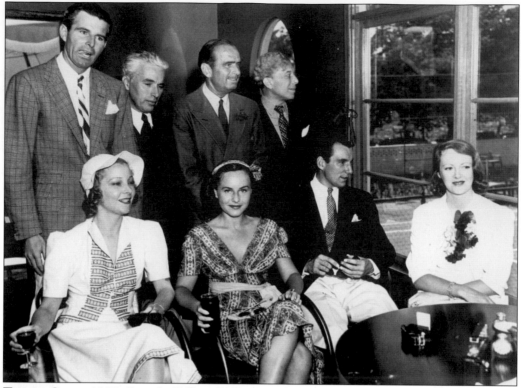

TENNIS CLUB, 1939. Beverly Hills celebrities used the clubhouse for private parties, tennis tournaments, and meetings. In early 1939, Charles Chaplin and Douglas Fairbanks host a private party at the clubhouse. Pictured, from left to right, are (seated) unidentified, Paulette Goddard (Mrs. Chaplin), unidentified, and Sylvia Ashley (Mrs. Fairbanks); (standing) unidentified, Charles Chaplin, Douglas Fairbanks, and Sid Grauman.

BEVERLY HILLS CELEBRITY MONUMENT, 1969. In 1923, Los Angeles was accepting annexations of small independent towns that were in need of Los Angeles water service. Beverly Hills debated the question and several movie star residents campaigned for a no vote. The nos carried the day. In 1959, actress Corinne Griffith spearheaded a tribute to the stars that helped save Beverly Hills as an independent city. An eight-sided stone column featuring the sculptured likenesses of eight celebrities was designed by sculptor Merrell Gage and erected on an island at the intersection of South Beverly Drive and Olympic Boulevard. The eight celebrities honored include Douglas Fairbanks, Mary Pickford, Will Rogers, Fred Niblo, Rudolph Valentino, Conrad Nagel, Tom Mix, and Harold Lloyd.

Ten

LANDMARKS AND INFRASTRUCTURE
1930–1940

Despite the Wall Street crash of November 1929, Beverly Hills did not truly feel the effects of the financial disaster until 1932. It was only 10 years since Beverly Hills had changed from a residential community to a city in its own right. Articles about Beverly Hills publicized the city as "beautifully rural, conveniently urban." During the Depression, there was a 52 percent gain in residents, even though many were forced to leave due to bankruptcy. The Beverly Hills Unemployment Bureau was established, and people were hired to work on civic improvement projects helping the city to survive the hard times. During the Depression, "specialty" shops opened with unusual items for sale, and when Saks Fifth Avenue opened a store on Wilshire Boulevard, advertisements claimed, "New York comes to Beverly Hills." Many of the stores in the city adopted large picture windows where visitors could see what was in style or what was available. Beverly Hills was gaining a new reputation as being the "Show Window of the World." Many motion picture celebrities lived in and around the area, and Beverly Hills was where they shopped and dined.

During the 1930s, the business district was developing into a concentration of stores and businesses. The Beverly Hills branch of the Brown Derby opened in 1931 at Wilshire Boulevard, and Rodeo Drive and became a favorite of the film colony who lived nearby. Owned by Robert Cobb, the Derby's busiest evening was Thursday night, when one could find most stars dining out. In December 1934, Victor Hugo's restaurant, on Beverly Drive near Wilshire Boulevard, became a local favorite for high-class parties when it moved from its downtown location.

Since its incorporation, Beverly Hills's city government offices were merely rented quarters in various parts of the town. In 1930, land was purchased from the Pacific Electric Railway for the future construction of a new civic center. In July 1931, construction contracts for a new city hall were signed and the new Spanish Colonial Baroque–style building was built. Opened in 1932, the city hall was a crowning achievement in the city and became an enduring landmark that could be seen for miles around.

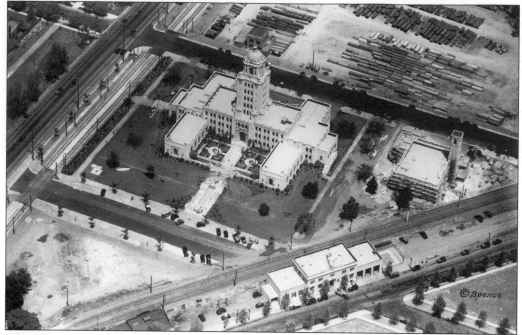

CITY HALL. The newly completed city hall building and landscaped grounds are visible in this April 1932 photograph. Adjacent to the city hall complex is the new Beverly Hills Fire Station (under construction), and at the bottom right is the old Beverly Hills City Hall building at Crescent and Burton Way. Shortly after this photograph was taken, the old city hall was demolished and Crescent Drive was united.

CITY COUNCIL CHAMBER, 1936. On January 2, 1914, Beverly Hills was incorporated as a city and the city officers were considered board of trustees. The first city council was formed officially on January 28, when a certificate of incorporation was bestowed by the secretary of state. It was not until 1927 that the California Legislature amended the law so that the trustees could act as councilmen and the president as mayor. The council chamber is of Spanish Renaissance design, like that of the neighboring courtroom.

POLICE DEPARTMENT, 1932. Shortly after the new city hall was completed, the officers of the Beverly Hills Police Department stood at attention for this group photograph on the rear steps of city hall. The chief of police at this time was Charles C. Blair. The department of around 60 included patrolmen, motor officers, detectives, and office managers.

ALL SAINTS EPISCOPAL CHURCH, 1930. In 1922, a small group of people gathered at the Beverly Hills Hotel. Four years later, $26,000 had been raised to buy the land to build the original chapel at Camden Drive and Santa Monica Boulevard (as seen here in this 1930 photograph). By 1935, All Saints had become a parish and, with it, continued growth and development. A larger church building and parish was built and dedicated in 1951, and the original church was preserved for use as the chapel.

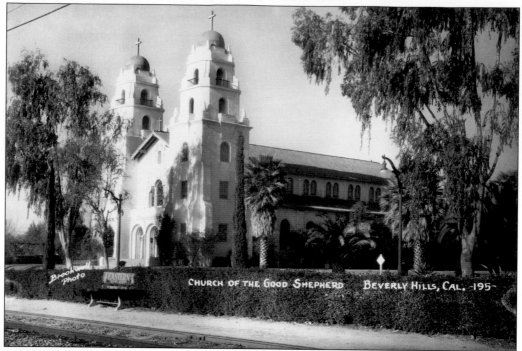

CHURCH OF THE GOOD SHEPHERD, 1936. In 1923, the Roman Catholic Bishop of Los Angeles established a parish in Beverly Hills named the Church of the Good Shepherd. The following year, the Mission–style church with is landmark twin towers was erected at the corner of Santa Monica Boulevard and Bedford Drive. The dedication of the building complex was on February 1, 1925. In 1959, major modernization of the church's interior and exterior was completed. Many of the more important historic weddings and funerals in Beverly Hills were held at the church—particularly the funeral of Rudolph Valentino in 1926.

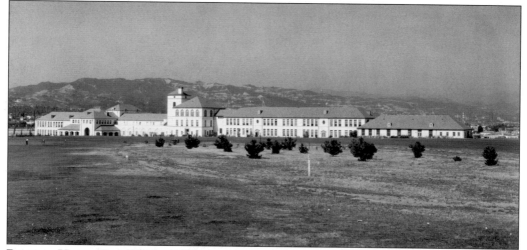

BEVERLY HILLS HIGH SCHOOL WESTERN PERIMETER, 1931. In 1927, the present high school buildings were designed by Robert F. Farquhar in the French Normandy style. By 1930, the desire to make Beverly Hills High a part of a Beverly Hills school system resulted in the formation of a Beverly Hills unified school district in 1935. The school was built on 19½ acres on the eastern border of the Fox Movietone Studio property, which later became Century City.

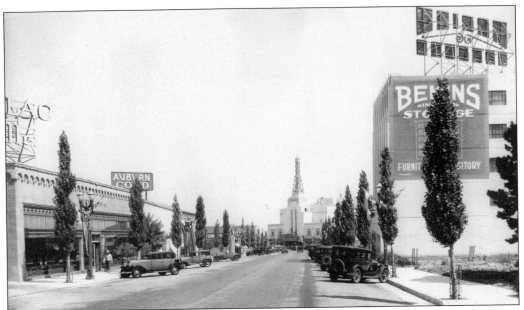

CANON DRIVE SOUTH TO WILSHIRE BOULEVARD, 1931. At the beginning of the 1930s, Canon Drive was becoming a commercial street between Santa Monica and Wilshire Boulevards. The Bekins Storage building, one of the first major commercial spaces on the block, was followed by the Cadillac and Auburn-Cord dealerships and several furniture showrooms. At the end of the block at Wilshire Boulevard, stood the new Warner Beverly Hills Theater that opened in May 1931, beginning a new business boom for the city. However, due to the Depression, most business and real estate development was stalled until the end of the 1930s.

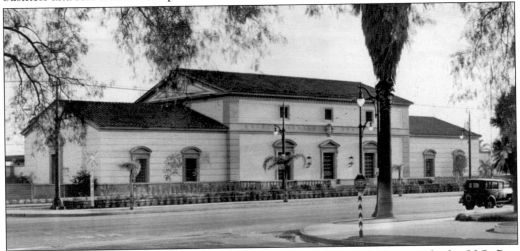

U.S. POST OFFICE, 1934. In 1930, after several failed communications with the U.S. Post Office Department in Washington, Beverly Hills celebrity resident Will Rogers wrote a letter to the secretary of the Treasury asking for help in getting Beverly Hills its post office. Due to the Rogers letter, Washington officials appropriated $300,000 for a new post office. Built on the original site of the Beverly Hills railway station on the southeast corner of Canon and Santa Monica Boulevard, architect Ralph C. Flewelling designed the building in Italian Renaissance style with terra-cotta and brick. An elaborate dedication and a weeklong "City Salute" was held on April 28, 1934, with hundreds of residents in attendance.

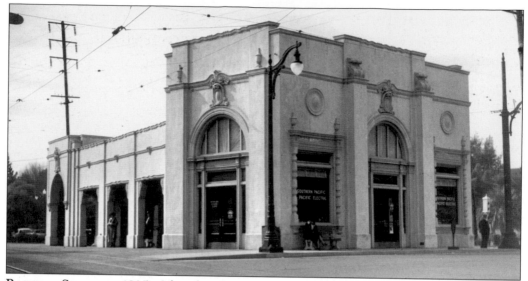

RAILWAY STATION, 1935. After the new post office was constructed on the site of the old railway station, a new one was built on the southwest corner of Canon Drive. The Southern Pacific and Pacific Electric Station was designed in Spanish-Baroque style and serviced the city for almost 20 years before it was replaced by the George Elkins Real Estate building.

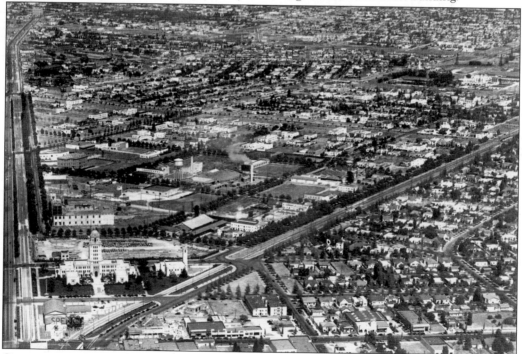

COMMERCIAL TRIANGLE, 1934. In this view of the Beverly Hills Commercial Triangle looking east, Beverly Hills City Hall is located at the western point of the triangle, with Santa Monica Boulevard on the left and Burton Way on the right. The city hall was built on the site of the Sun Lumber Company. Other than the Holsum Bakery building behind the city hall, there was little development of the triangle during the Depression period. It kept the city moderately stable through hard times, though.

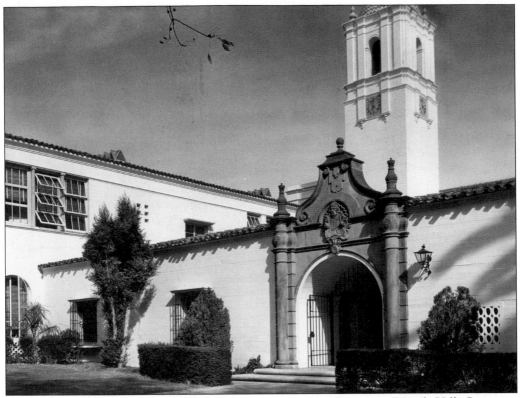

HAWTHORNE SCHOOL, 1939. In 1915, five acres were acquired to erect a Beverly Hills Grammar School (Hawthorne). The school property was later moved to the second block of Rexford Drive, above Santa Monica Boulevard. An Italian villa–style structure was built, and in the first year, 35 pupils were enrolled. By the next year, there were 80 students, and by 1924, new buildings were added to handle the growth in student attendance. By the 1930s, the entire school was remodeled into a Spanish Colonial–style building complex, complete with a bell tower.

HORACE MANN SCHOOL, 1939. Located at 8701 Charleville at Rexford Drive, the Horace Mann School was opened in December 1929 to handle the influx of students that was overcrowding Hawthorne (1915), Beverly Vista (1925), and El Rodeo (1927) Schools. The new school cost $232,000 and was designed in the Spanish Colonial style, like many of the other public structures in the city. The detail work included Spanish tile decoration, wrought-iron window bars, and a Spanish tile roof, making it blend into the neighborhood.

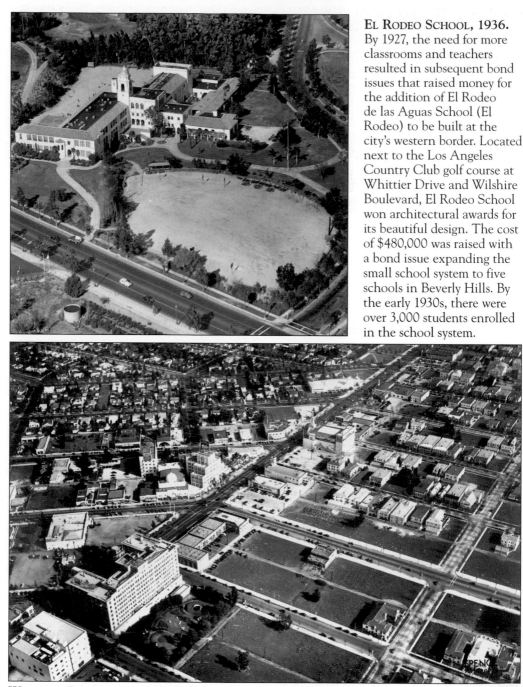

EL RODEO SCHOOL, 1936. By 1927, the need for more classrooms and teachers resulted in subsequent bond issues that raised money for the addition of El Rodeo de las Aguas School (El Rodeo) to be built at the city's western border. Located next to the Los Angeles Country Club golf course at Whittier Drive and Wilshire Boulevard, El Rodeo School won architectural awards for its beautiful design. The cost of $480,000 was raised with a bond issue expanding the small school system to five schools in Beverly Hills. By the early 1930s, there were over 3,000 students enrolled in the school system.

WILSHIRE BOULEVARD AND BEVERLY DRIVE, 1937. At this time, the heart of business in Beverly Hills had moved from Beverly Drive and Santa Monica Boulevard to Wilshire Boulevard and Beverly Drive. With the coming of the 1930s, the intersection at Wilshire Boulevard began to resemble a downtown district, which included the Beverly Wilshire Hotel, the Beverly Theater, the California Bank Building, Victor Hugo's Restaurant, office buildings, Warner Beverly Theater, and a couple of department stores. In 1937, South Beverly Drive was almost completely undeveloped until the beginning of the 1940s.

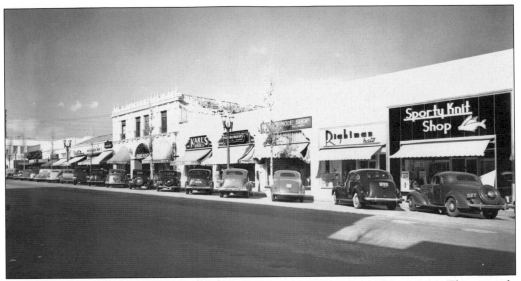

BEVERLY DRIVE NORTH BETWEEN SANTA MONICA AND BRIGHTON WAY, 1939. The east side of Beverly Drive shows many diverse businesses, many of which were considered "specialty" shops that were successful in surviving the Depression. Some of the shops pictured here on Beverly Drive included Sporty Knit Shop, a hat store, a millinery shop, Karl's shoes, a children's shop, flower shop, stationers, and a cafe.

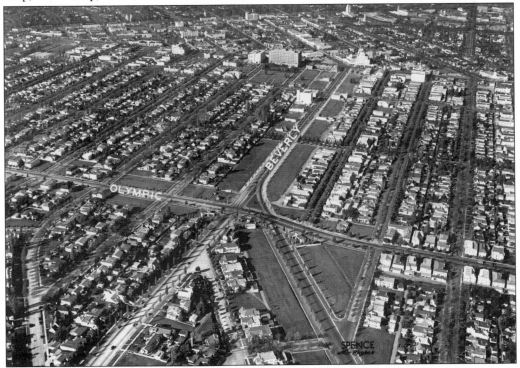

SOUTH BEVERLY DRIVE AT OLYMPIC BOULEVARD, 1939. Throughout the 1930s, South Beverly Drive was almost completely undeveloped due to lack of investment during the entire decade of the Depression. The residential area, however, had already been developed, creating a need for the Beverly Drive business district to begin the move south at the beginning of the 1940s.

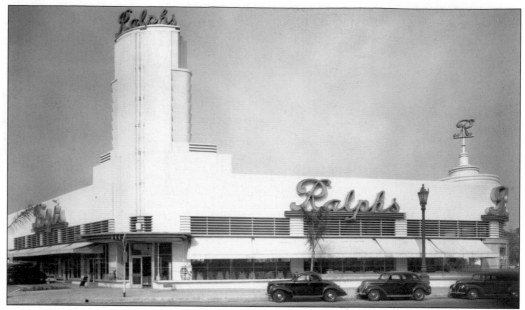

RALPHS MARKET, 1939. Ralphs Market, located at the northeast corner of Wilshire Boulevard and Crescent Drive, was designed in the Streamline Moderne style. The architectural body of the building was a horizontal box, opened both to the street and to the parking lot by a continuous band of horizontal plate glass windows. At one corner, dominating the whole, was a huge "Festoonal tower." Architect Stiles O. Clements designed these buildings for Ralphs with the company sign and building as one structure.

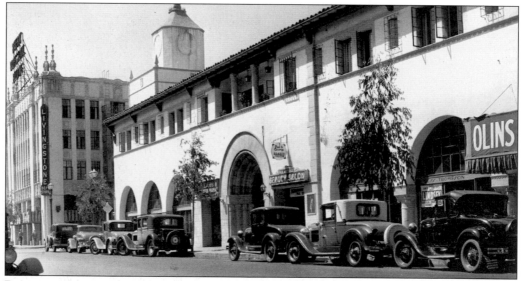

BRIGHTON WAY AND CAMDEN DRIVE, 1935. The Beverly Hills Midway Building was designed as an Italian Romanesque–style building that was built for multi-use. The upper floors were offices and the street level was designed for storefronts. At this time, there were several businesses in the Midway building: Bess Thompson Shop, Paul and George Beauty Salon, and Plato's Pharmacy. Many new buildings were built on Wilshire Boulevard, including Simon's Drive-In restaurant; I. Magnin and Company (1939), designed by Myron Hunt and H. C. Chambers; and Saks Fifth Avenue (1936–1937), designed by John and Donald B. Parkinson and Paul Williams.

INTERSECTION OF WILSHIRE AND SANTA MONICA BOULEVARDS, 1938. This is an eastward-facing view down Wilshire Boulevard. Several businesses had been located there since the late 1920s. In 1938, businesses included Tip's Steaks and Sandwiches, Read and Wright Real Estate, Caillet Pharmacy, The Marketplace, Mae's Liquor Store, Standard Gasoline Station, and the famous Armstrong and Schroeder Cafe.

WILSHIRE BOULEVARD AND BEVERLY DRIVE, 1938. A circus parade comes to Beverly Hills at the intersection of Beverly Drive and Wilshire Boulevard. By the end of the 1930s, this intersection was considered the downtown of Beverly Hills. The Beverly Theater was showing John Boles and Loretta Young in *The White Parade* and George Raft and Anna May Wong in *Limehouse Blues*.

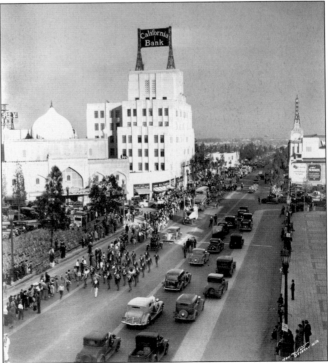

I. MAGNIN AND COMPANY, 1938. The original I. Magnin and Company shops on Wilshire Boulevard at Camden Drive featured three storefronts. In the 1940s, the company built a modern, multistoried department store on the site. Large department stores started to build on Wilshire Boulevard in the early 1930s, and by the late 1940s there were several important national department stores in Beverly Hills.

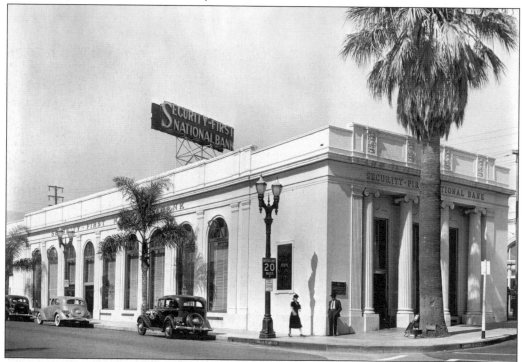

SECURITY FIRST NATIONAL BANK BUILDING, 1938. Originally, in 1922, this building on the southwest corner of Burton Way (South Santa Monica Boulevard) and Canon Drive was the Beverly State Bank. In 1924, it was acquired as the Beverly Hills office of Security Trust and Savings Bank, and by 1929, the bank again changed hands to become the Security–First National Bank of Los Angeles at 469 Canon Drive.

HARROLD'S RESTAURANT, 1936. One of the more unusual architectural oddities in Beverly Hills at this time was Harrold's Charcoal Broiled Steakhouse at Wilshire and Bedford Drive. The combination of Streamline and Zigzag Moderne style created an instant landmark for many years until it disappeared in the 1960s. Other restaurants became famous in Beverly Hills during the 1930s. Victor Hugo's restaurant moved from downtown Los Angeles to Beverly Hills at the end of 1934, and Harry Sugarman opened The Tropics restaurant on Rodeo Drive in 1936.

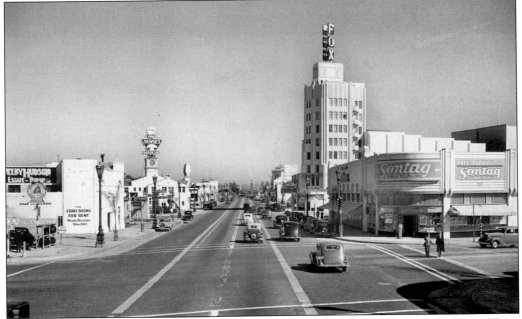

WILSHIRE AND LA CIENEGA BOULEVARDS, 1938. Looking east along Wilshire Boulevard from La Cienega, the Fox Wilshire Theatre tower became a Beverly Hills landmark as soon as it opened in 1930. On the southeast corner of La Cienega and Wilshire Boulevards was Sontag Drug Store. On the north side of Wilshire Boulevard, one can see the Sunset Gasoline Station, and further down, the Curries Ice Cream sign.

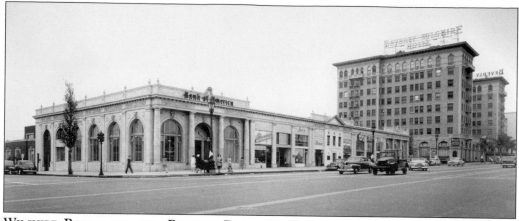

WILSHIRE BOULEVARD AND BEVERLY DRIVE, 1939. On the southwest corner of Wilshire Boulevard and Beverly Drive was a complex of high-quality shops, with the Bank of America on the corner. At this time, the specialty shops took on the reputation of being "high quality," separating them from most shops in the Los Angeles area. Some of the stores pictured here include Alexander Flowers, Marin Furs, Anna, Tavert and Hoeffer, a confectionery store, Mayfair Shops, Chryson Stationers, and TWA.

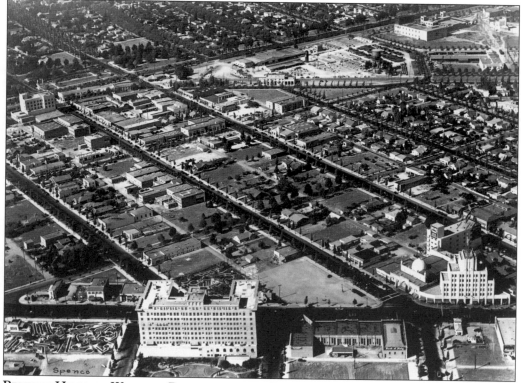

BEVERLY HILLS AT WILSHIRE BOULEVARD AND BEVERLY DRIVE, 1930. By the 1930s, Beverly Hills had come out of a major real estate boom and into a depression, without much growth potential. The center of business was on Beverly Drive between Santa Monica and Wilshire Boulevards. Beverly Drive businesses were predominately near Santa Monica Boulevard, with most of the street remaining residential or empty lots. Rodeo, Beverly, Canon, and Crescent Drives continued to be residential throughout the 1930s.